SUPERNATURAL™

THE OFFICIAL COLORING BOOK

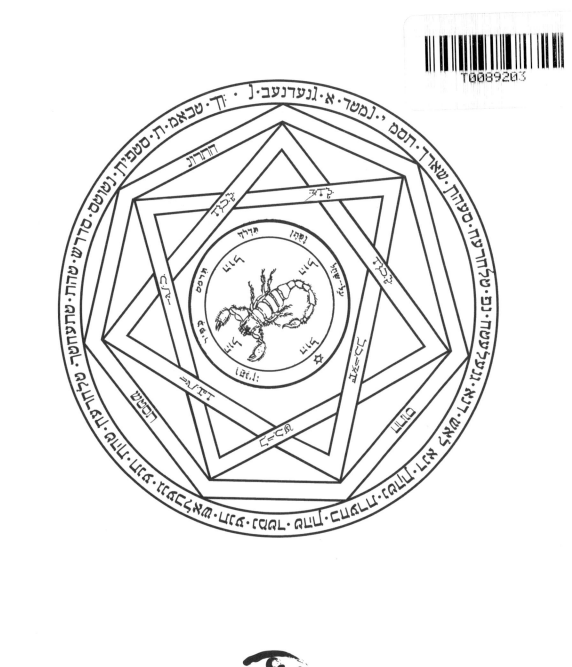

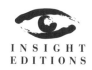

INSIGHT
EDITIONS

San Rafael, California

Ever since their mother was killed by the Yellow-Eyed Demon, Sam and Dean Winchester have literally gone to Hell and back hunting supernatural creatures. From killer clowns and hex bags to creepy one-star motel rooms, *Supernatural* is packed with otherworldly color and intricate sigils to explore. So grab your rock salt and pencils, and get to know everything from the Devil's Trap to angel blades up close and personal as you color your way through the world of the Winchester brothers.

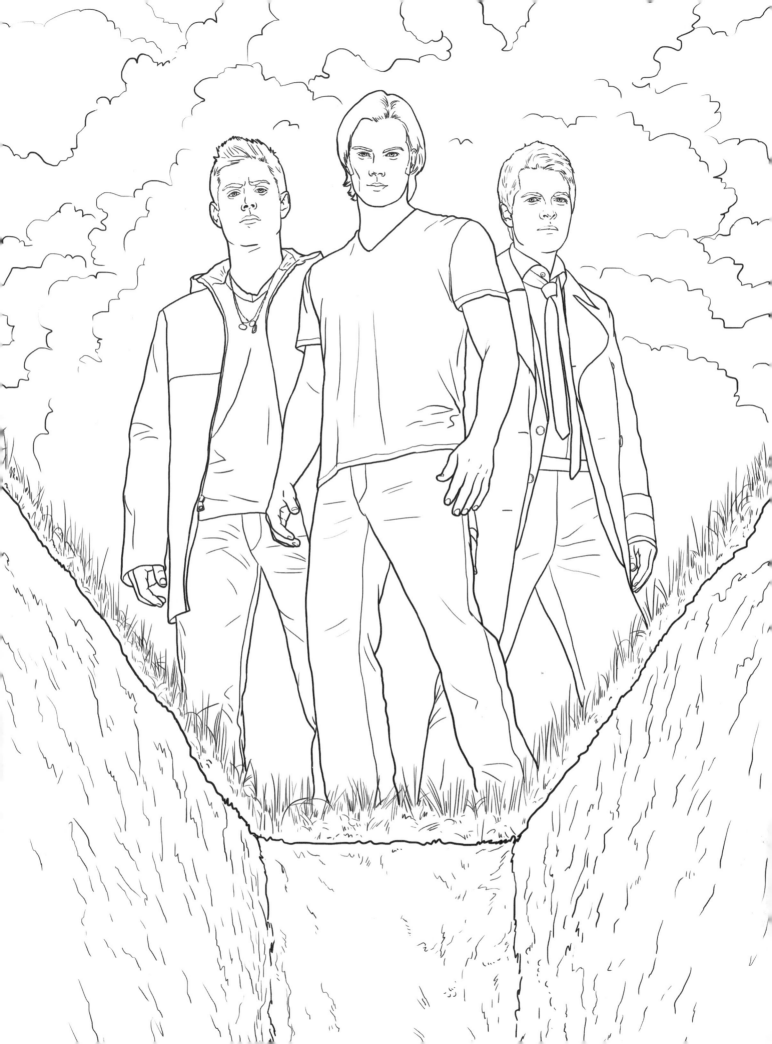

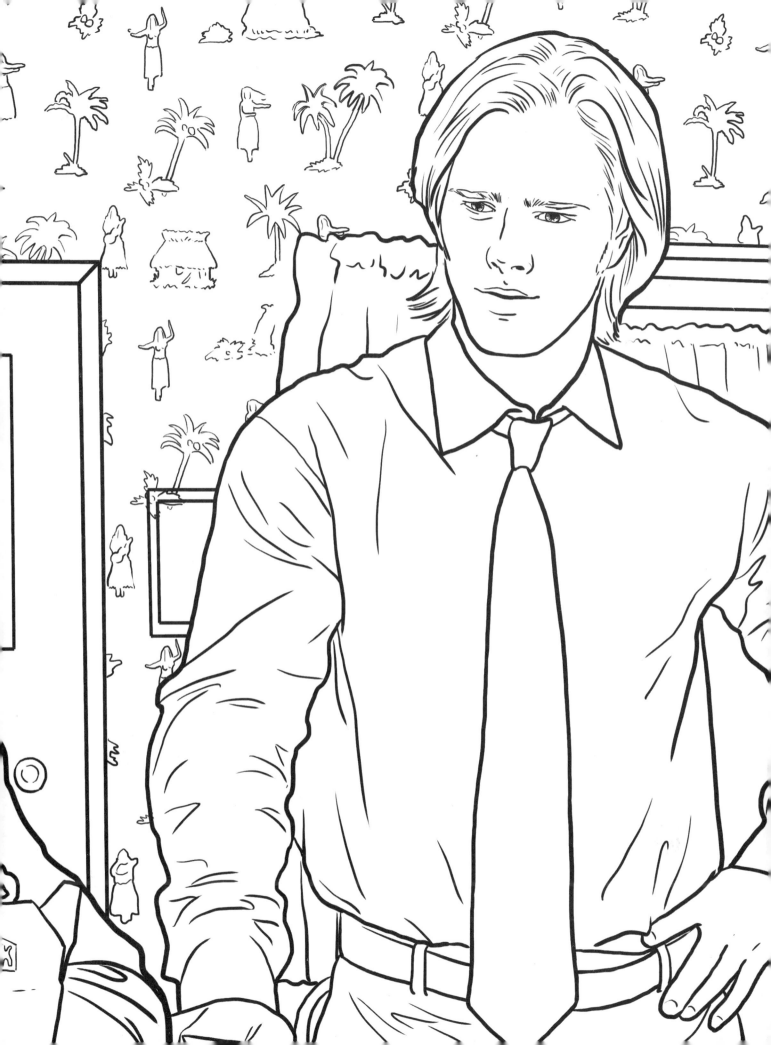

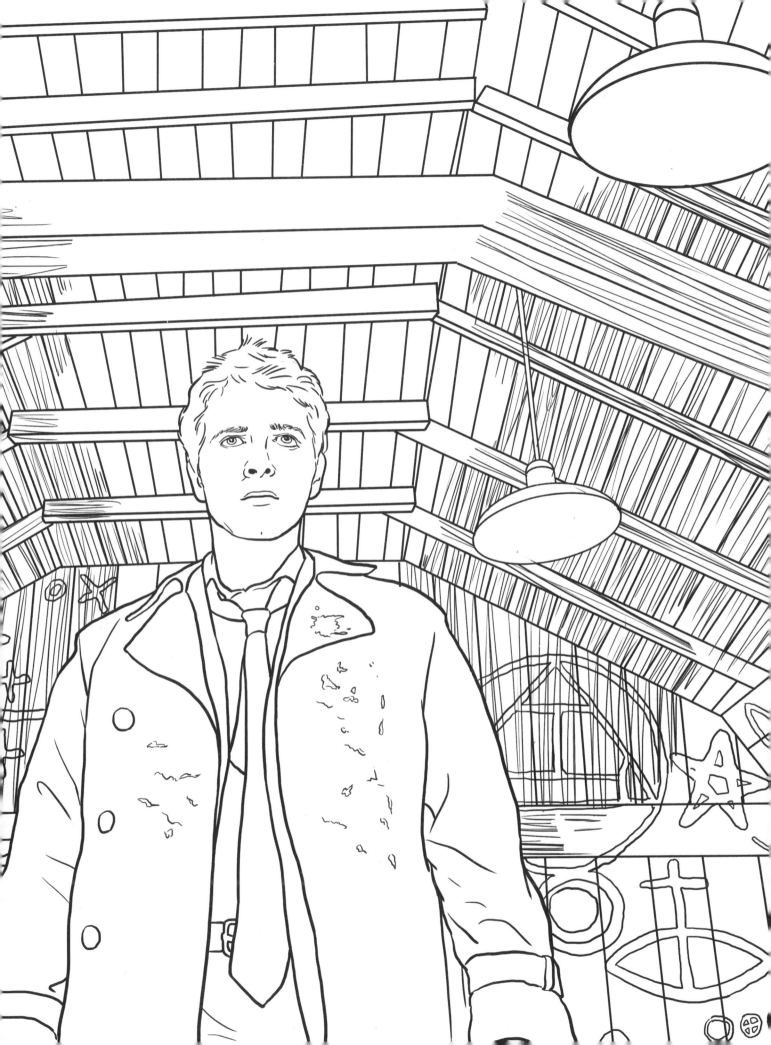

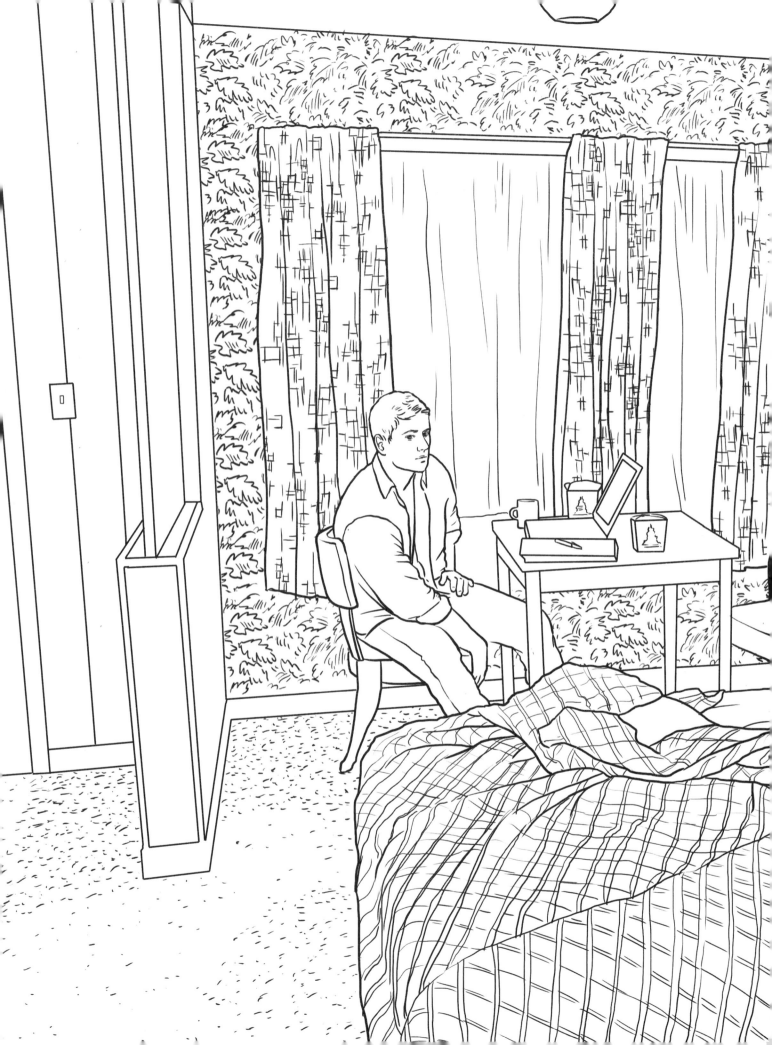

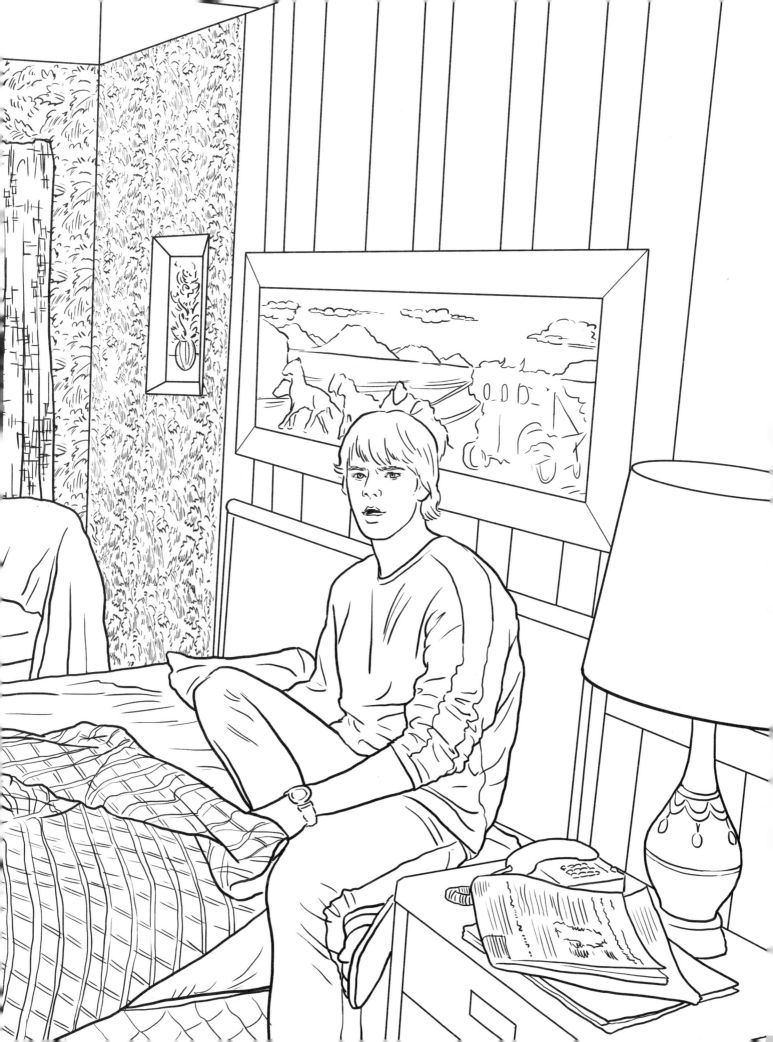

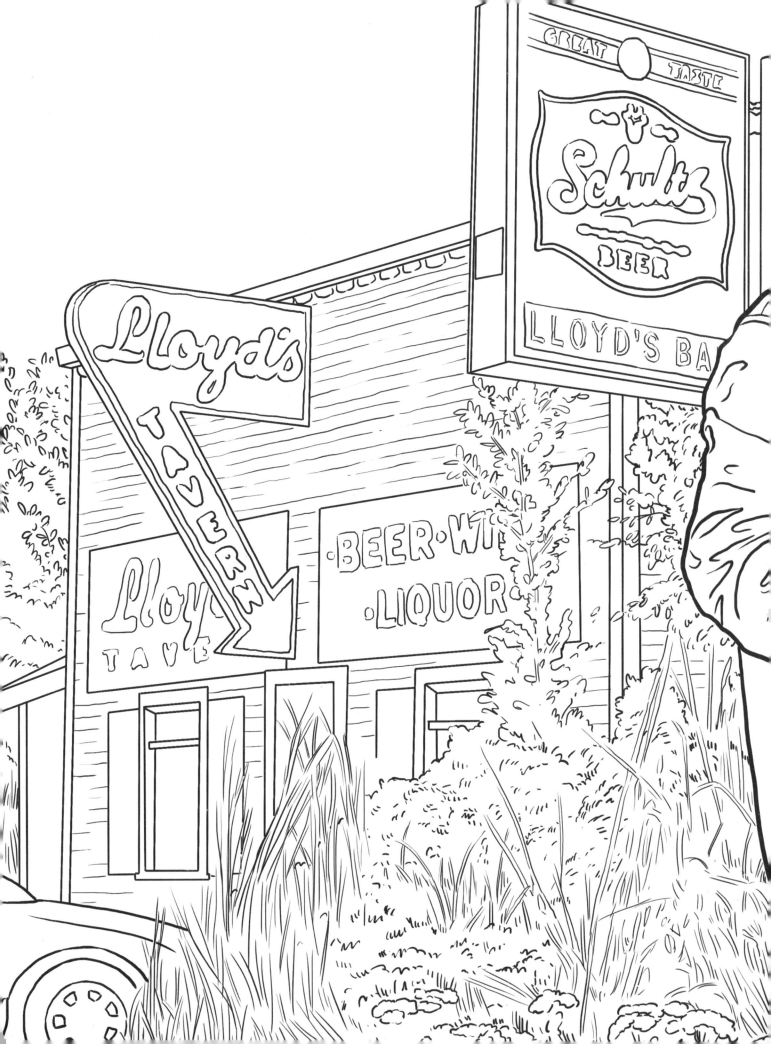

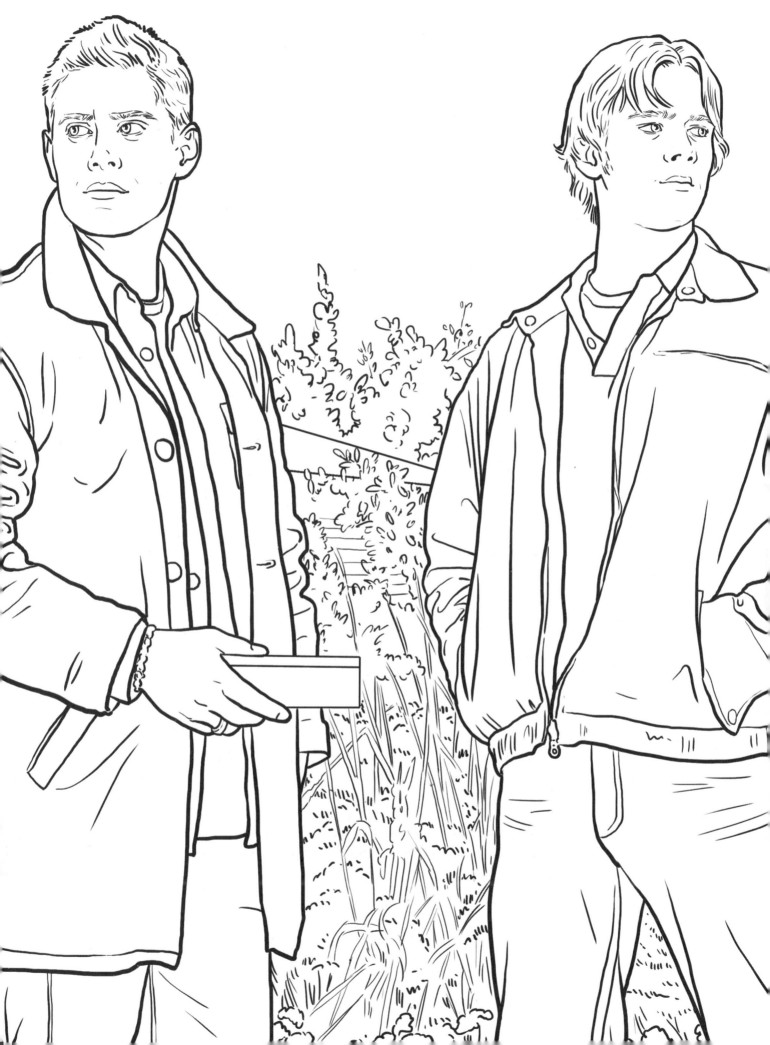

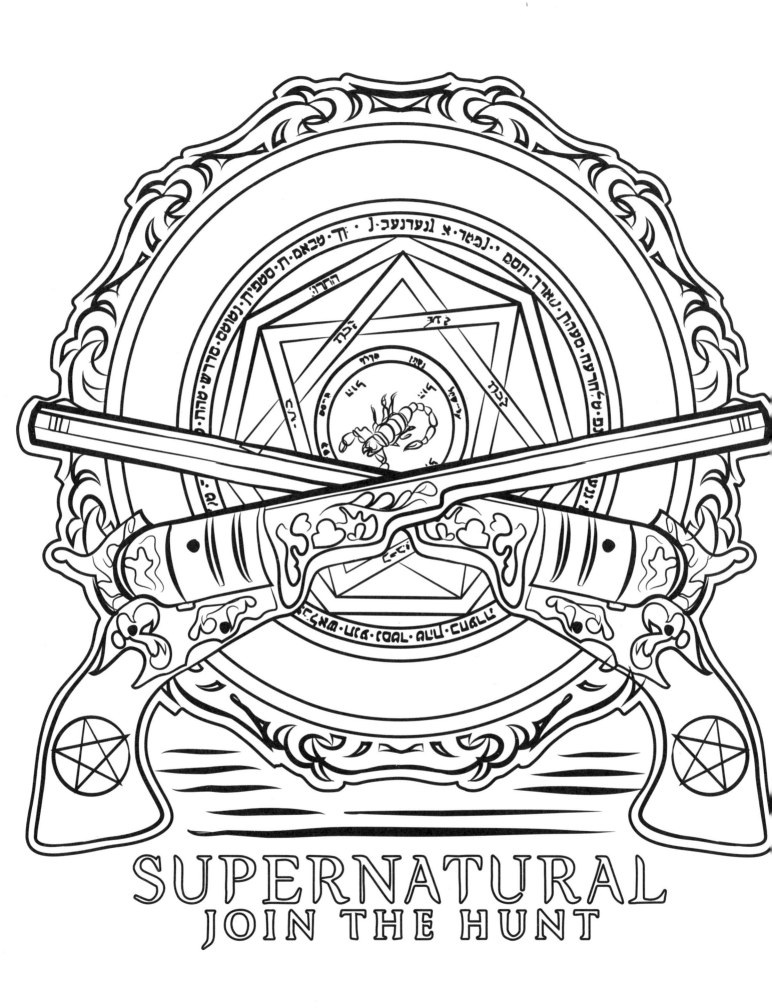

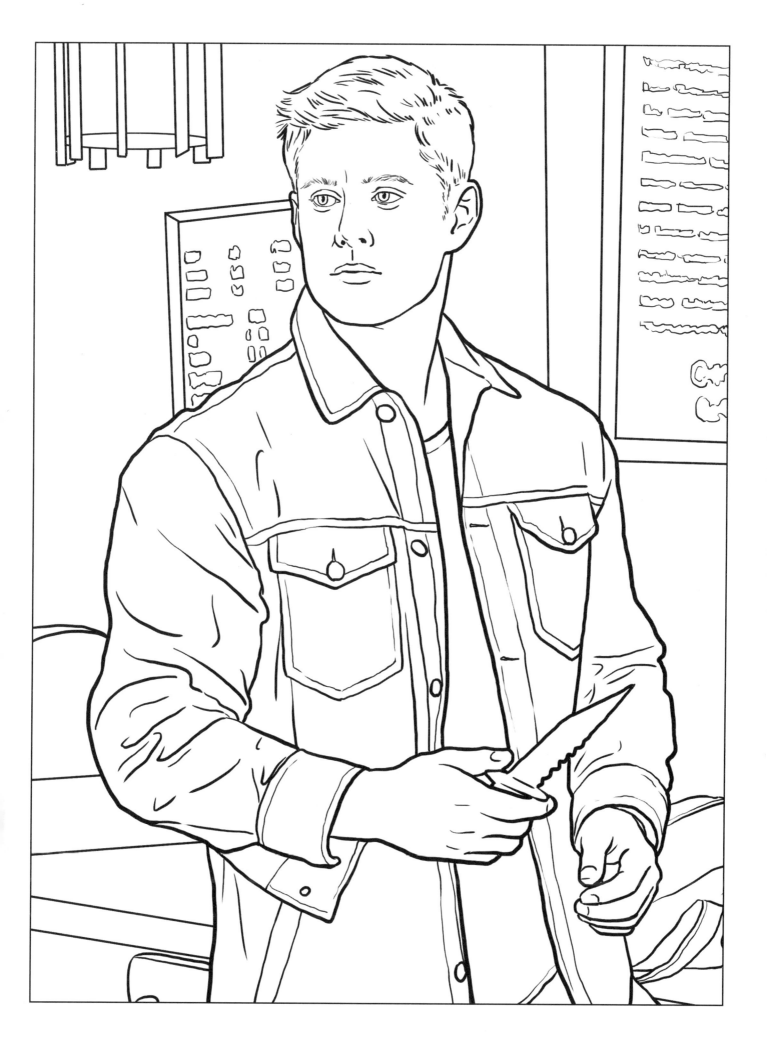

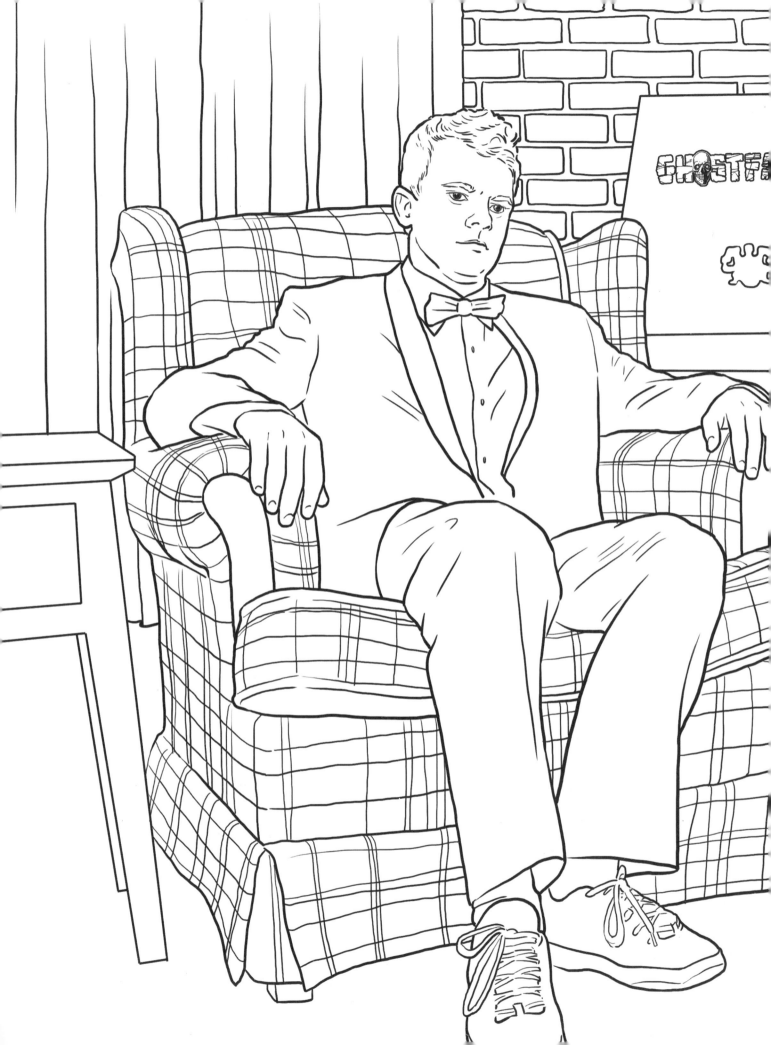

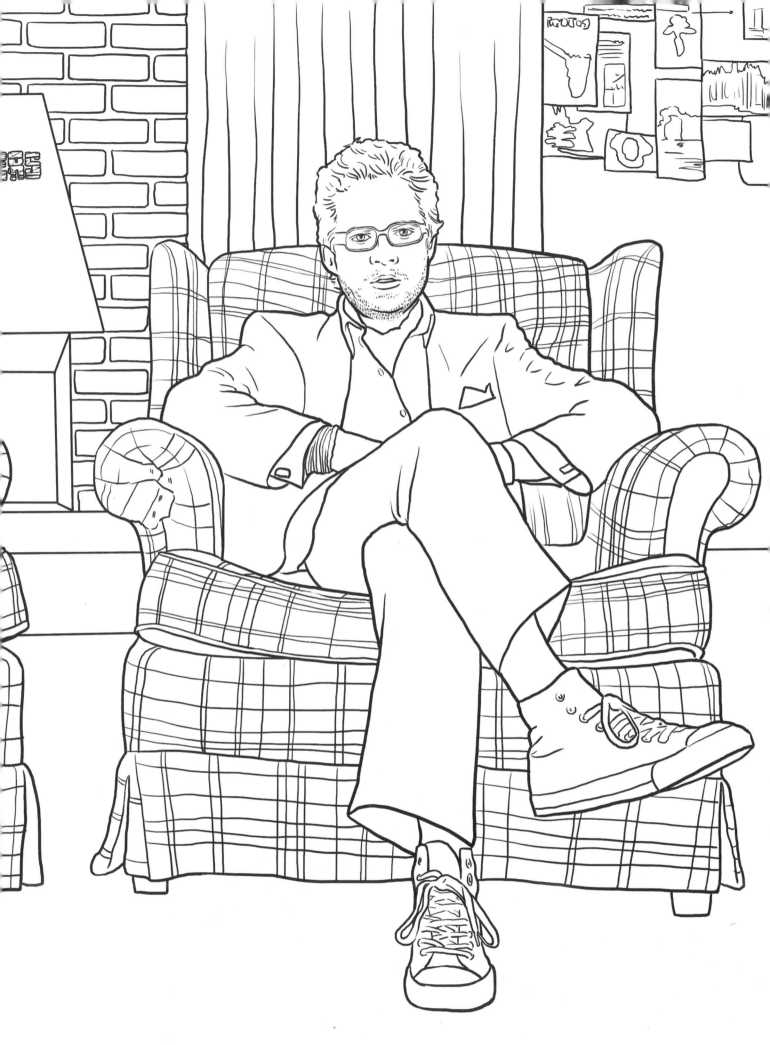

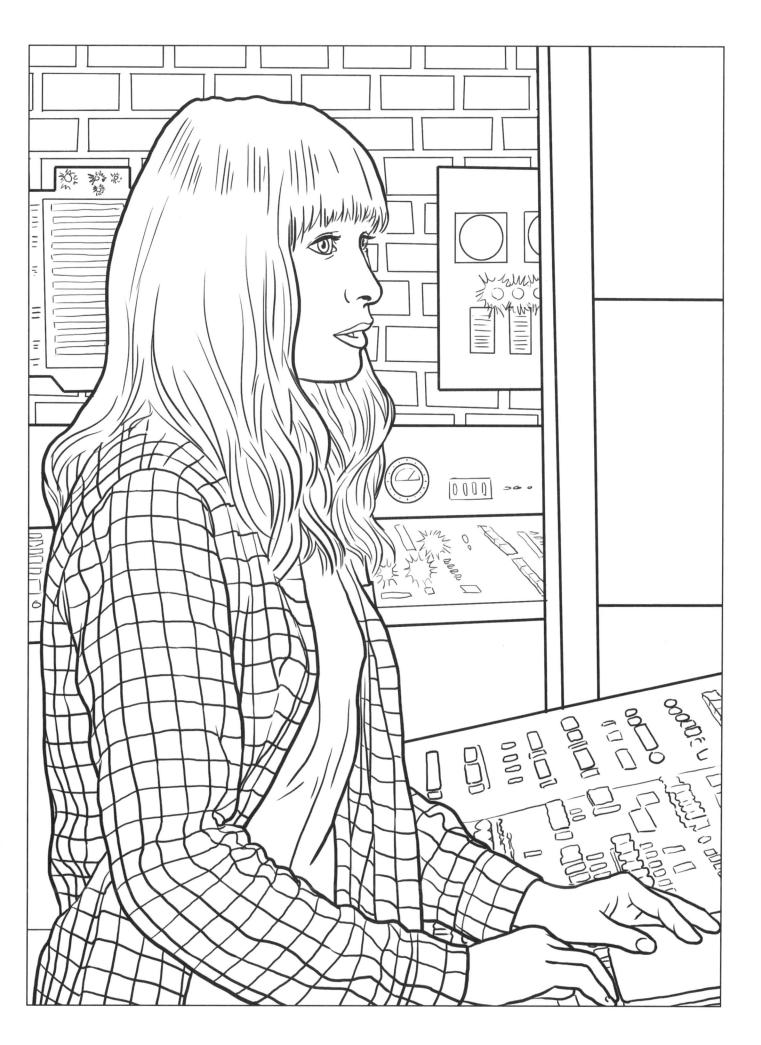

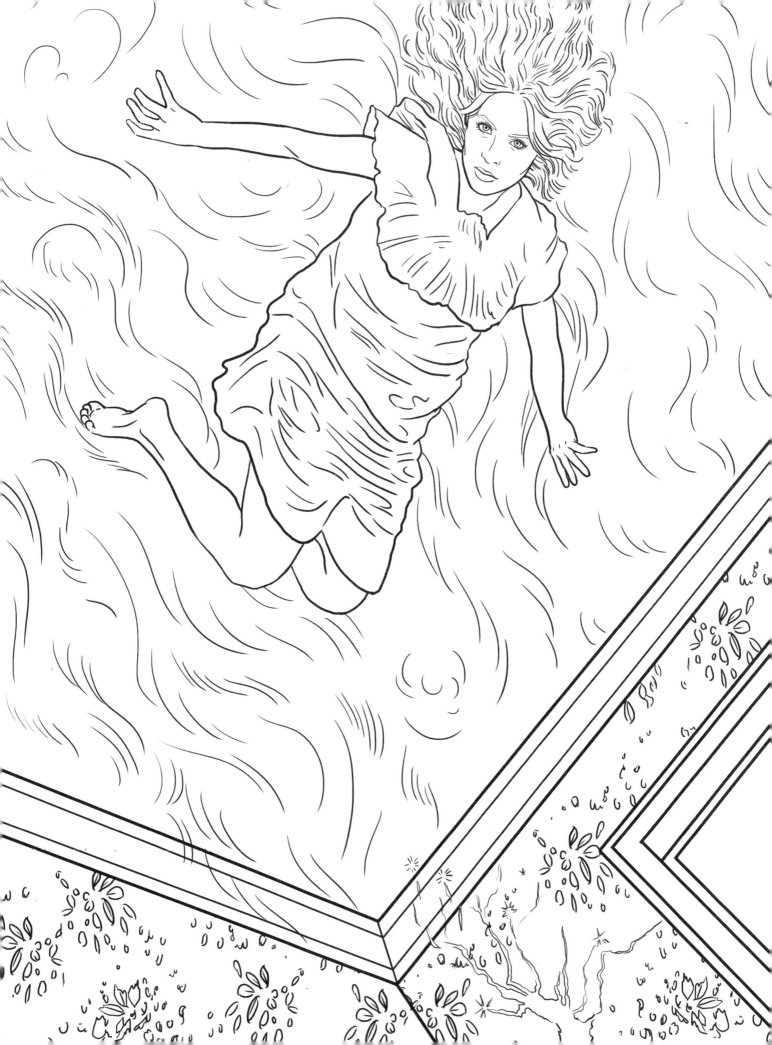

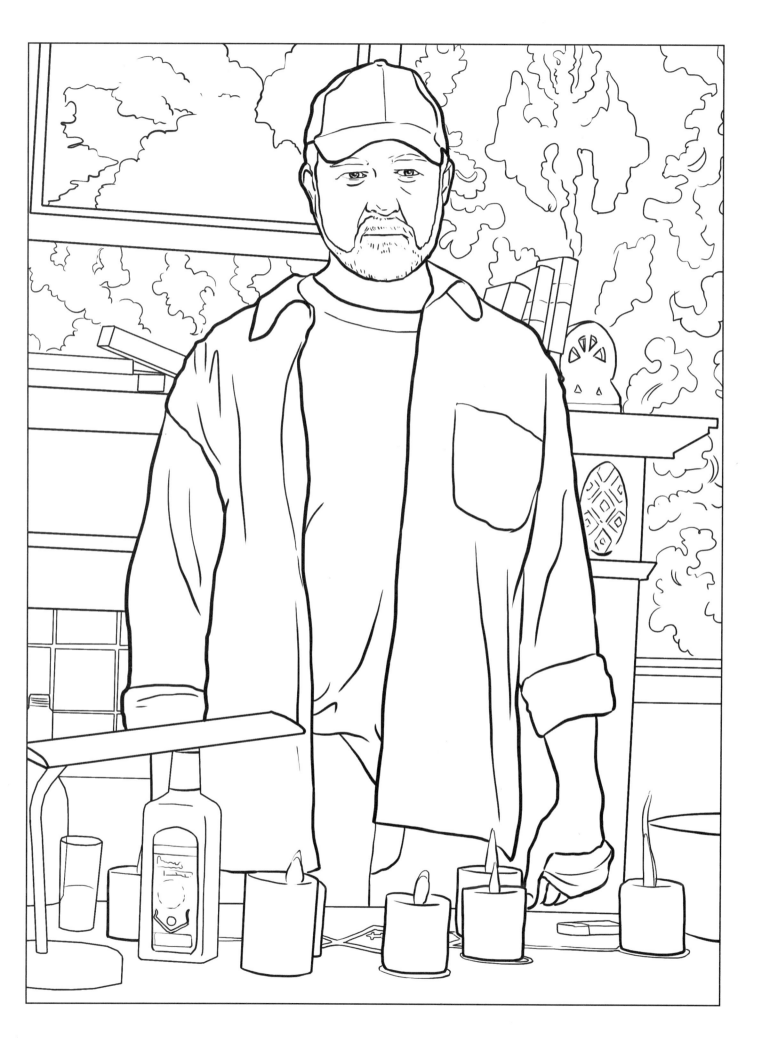

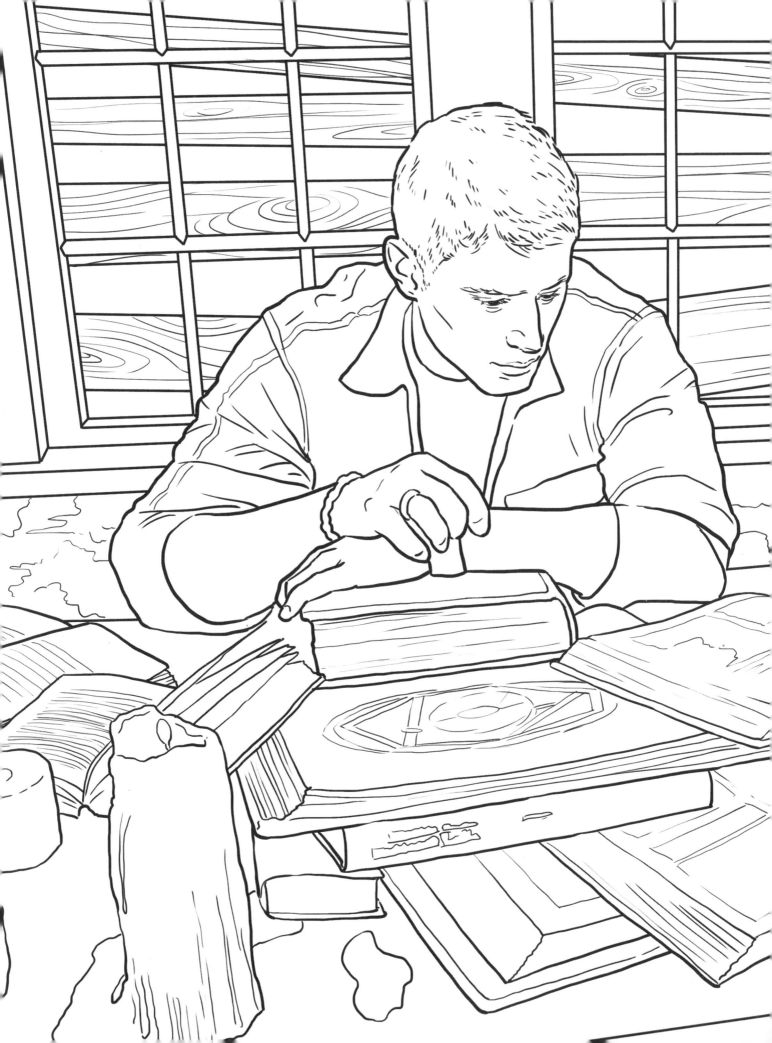

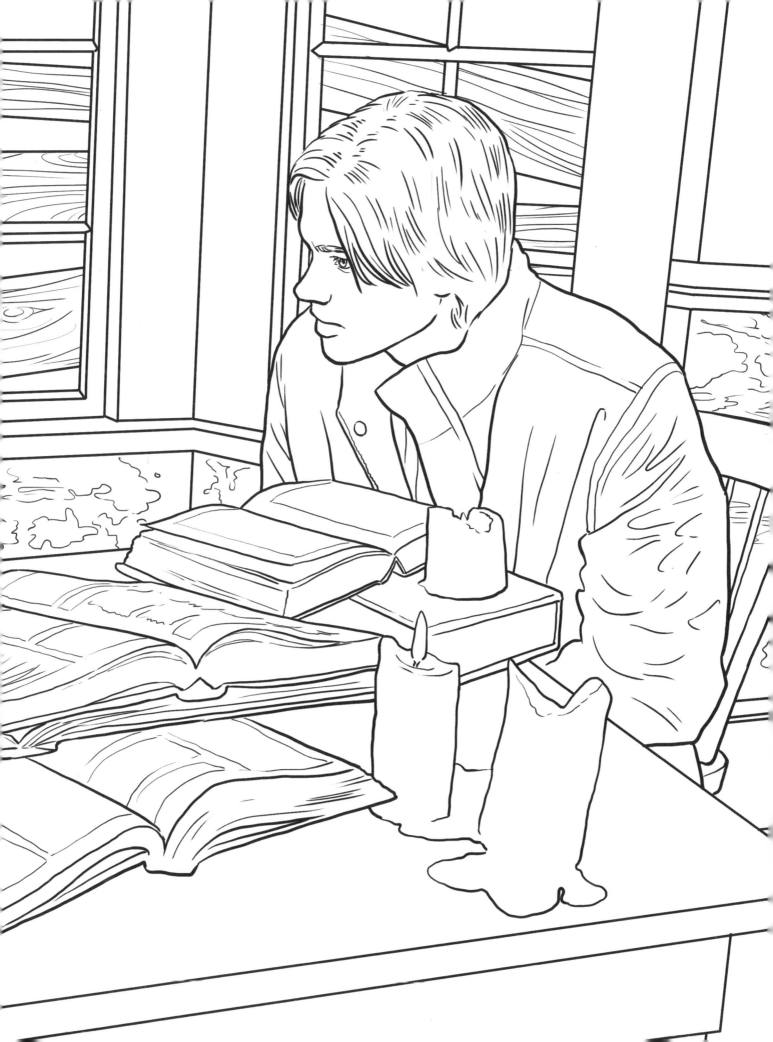

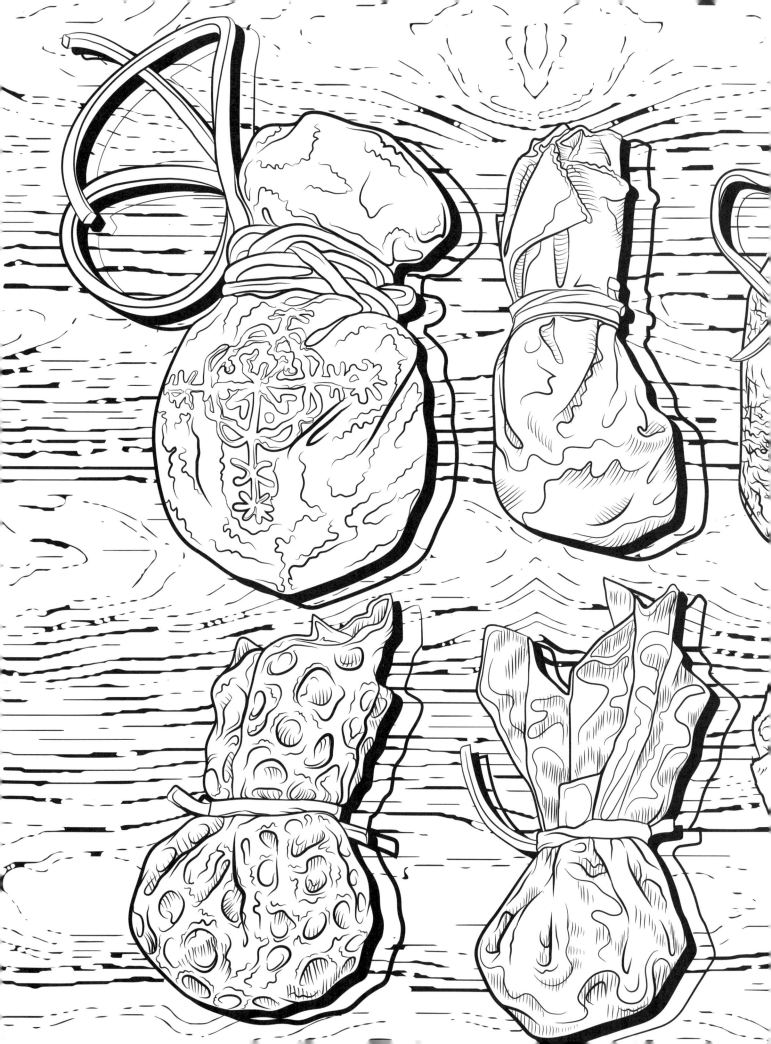

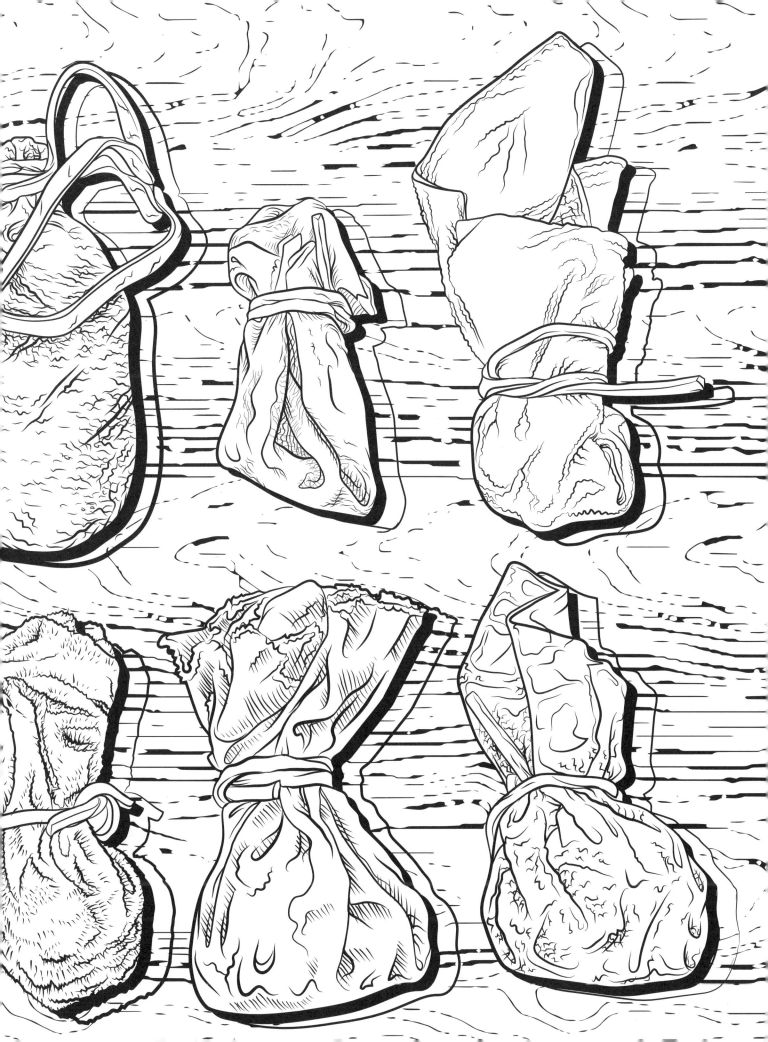

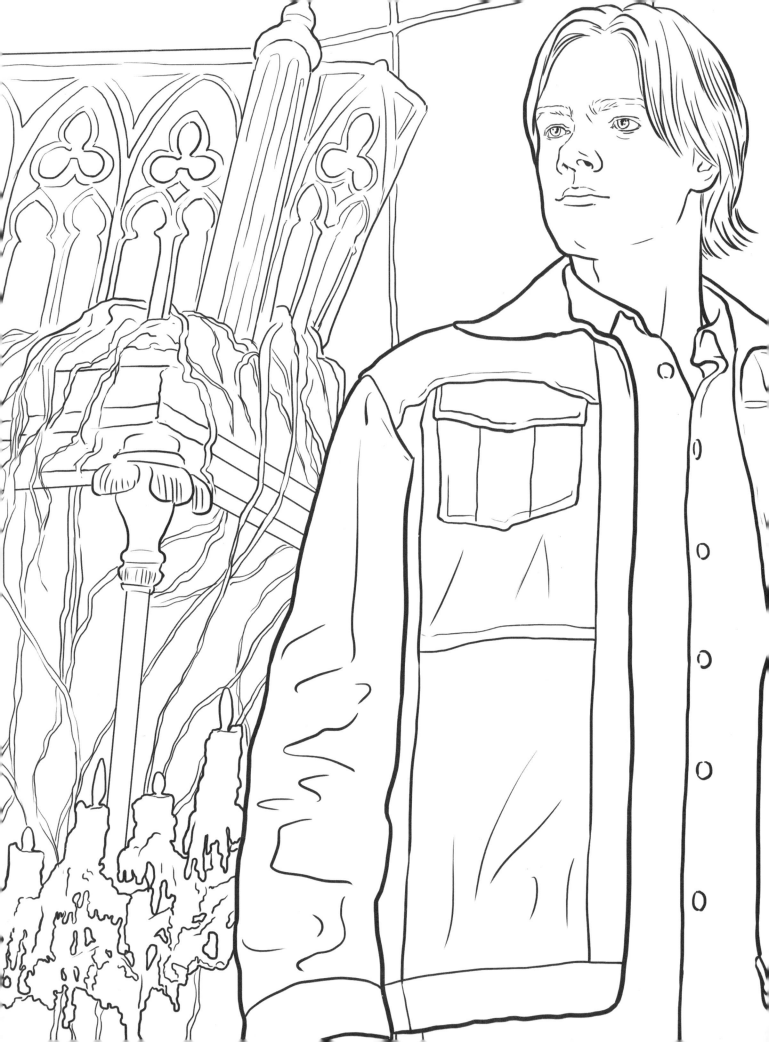

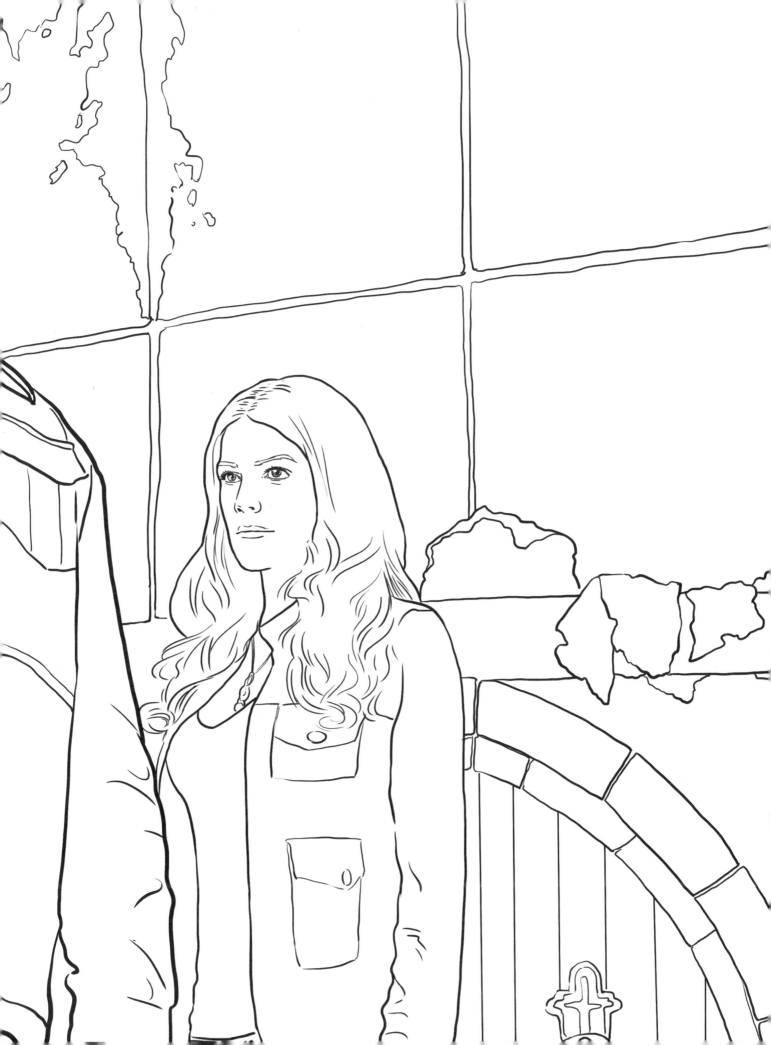

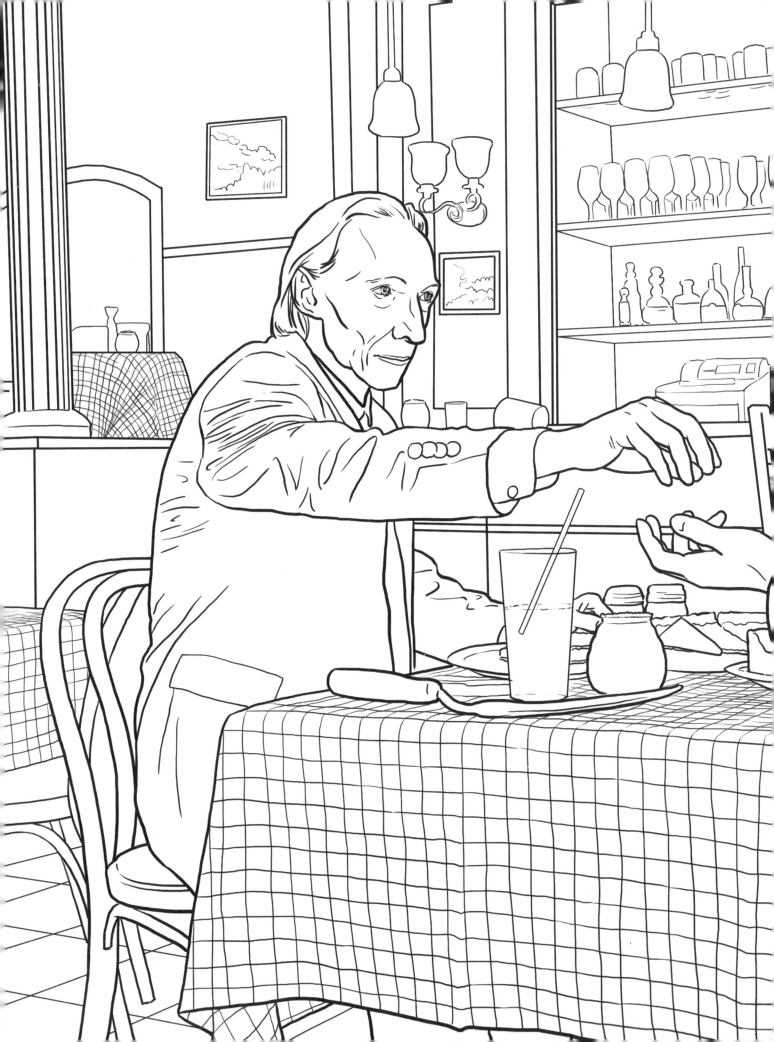

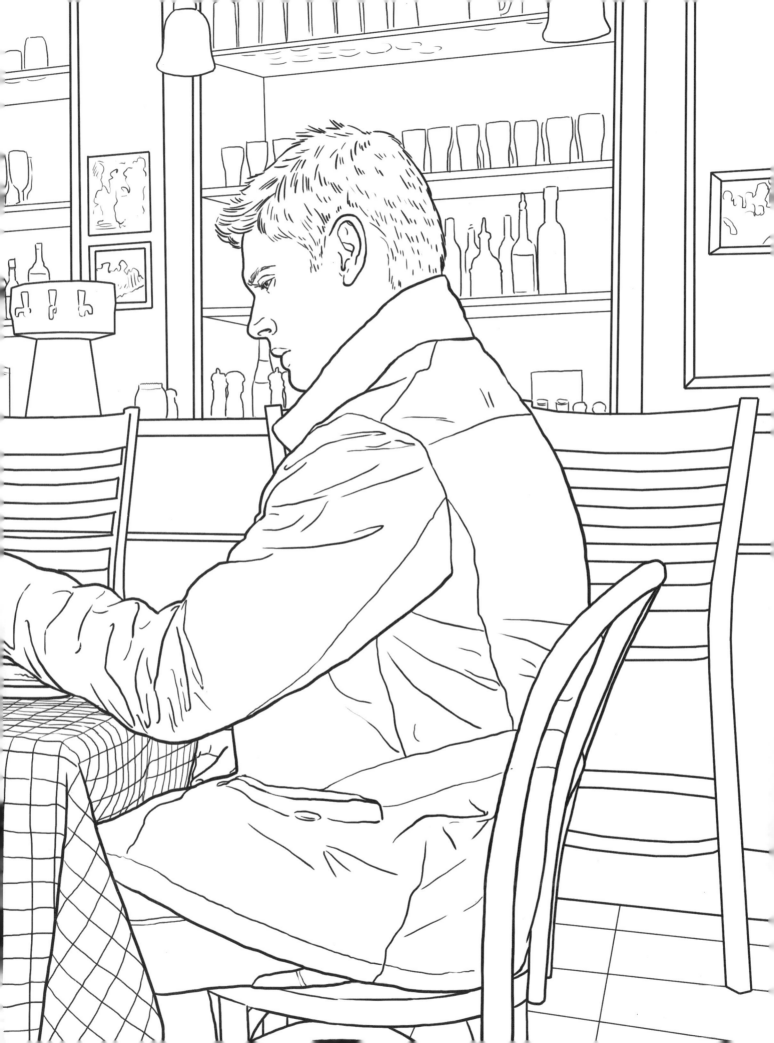

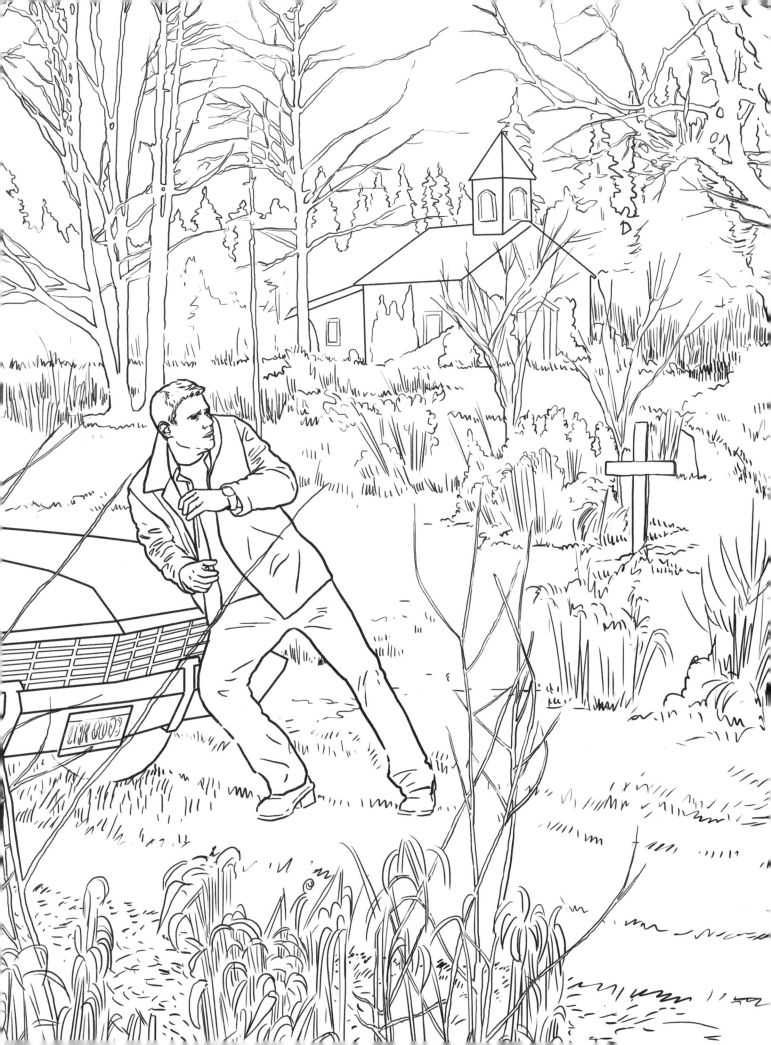

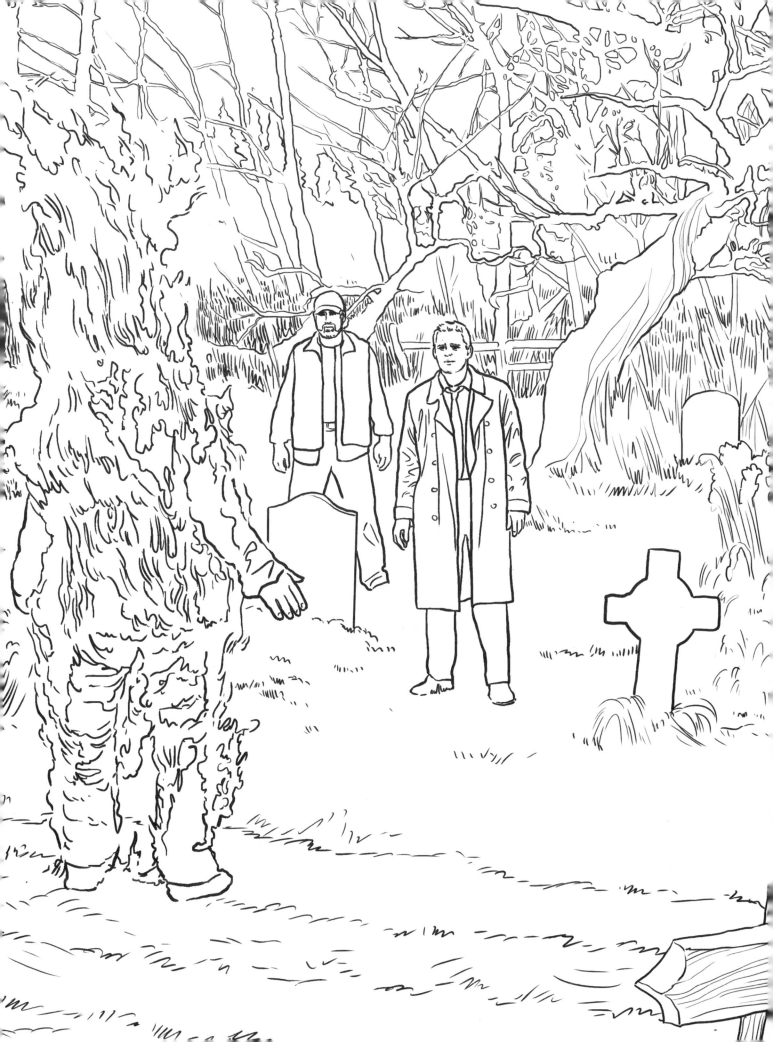

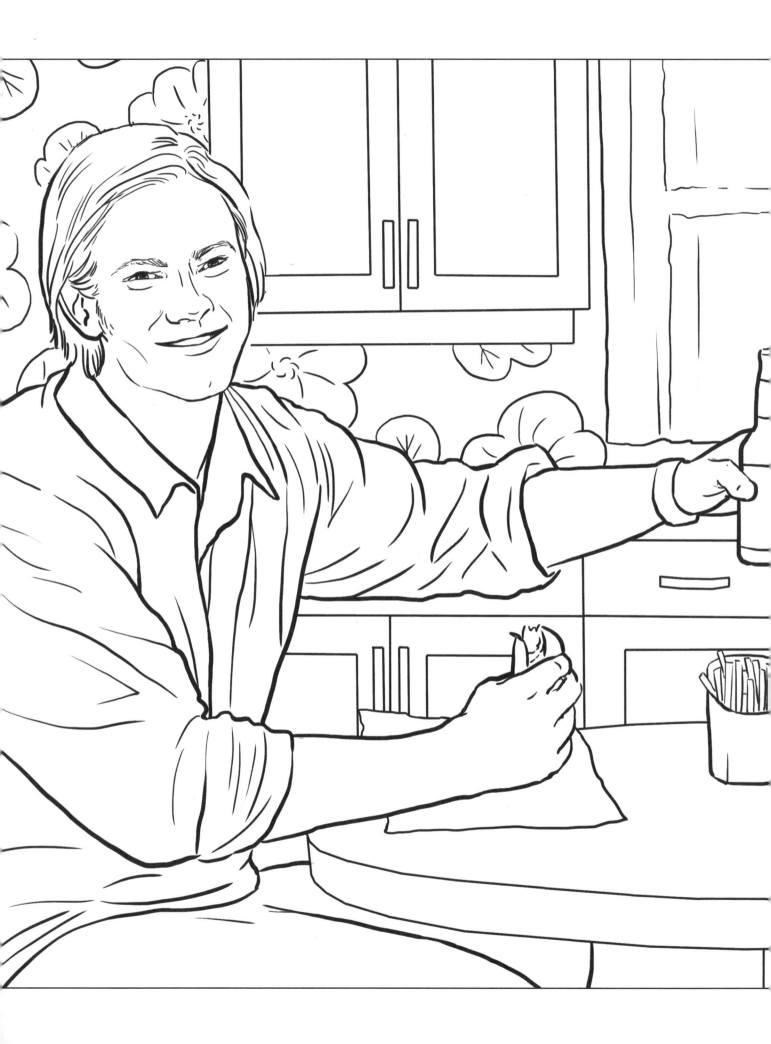

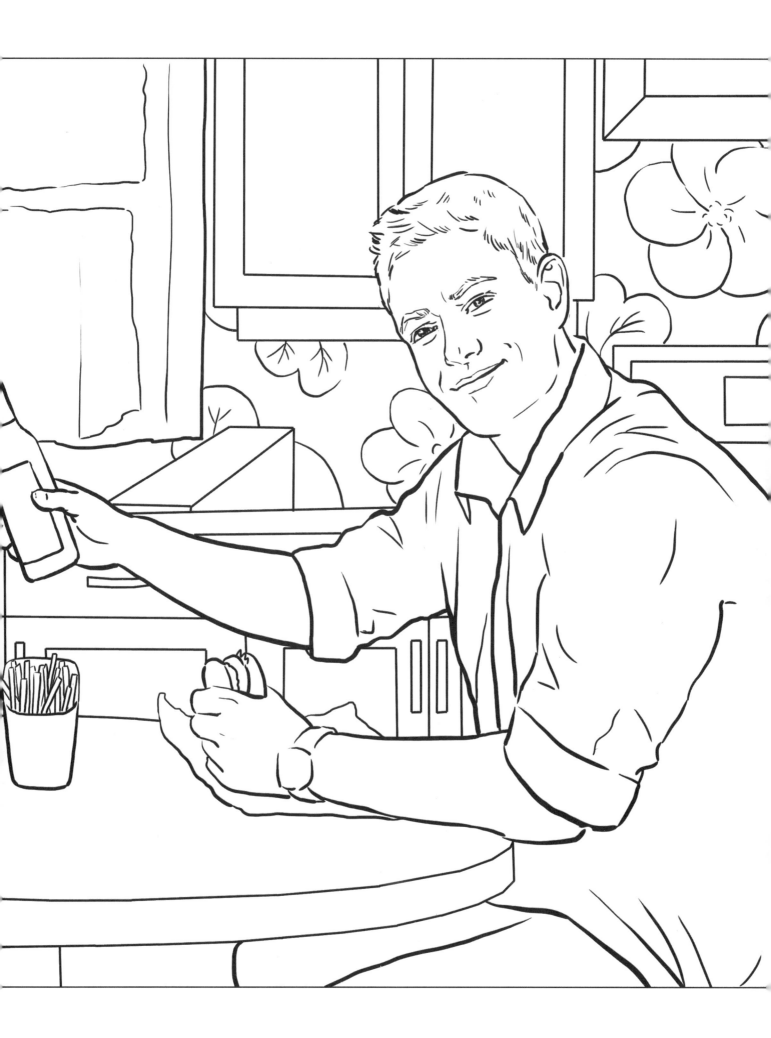

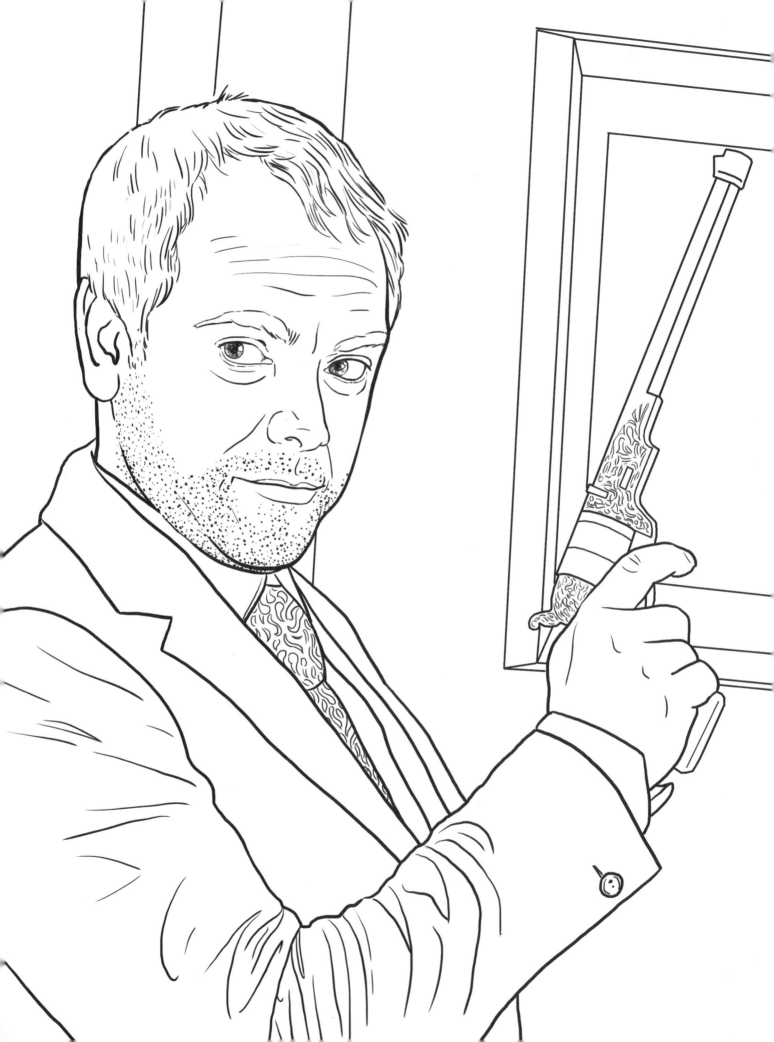

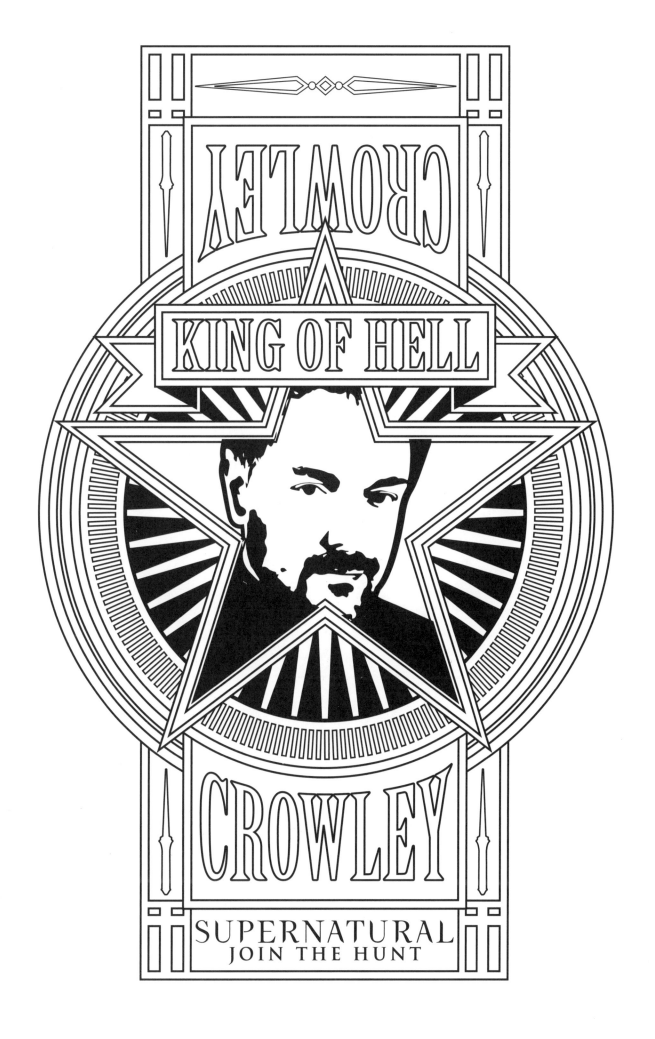

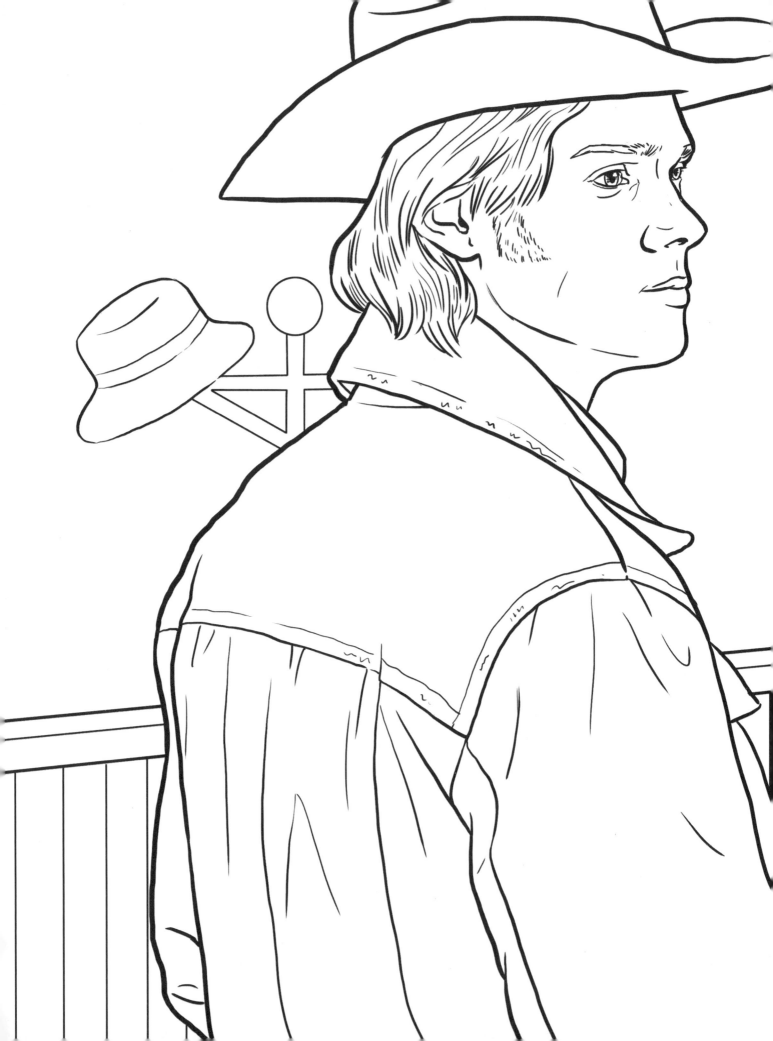

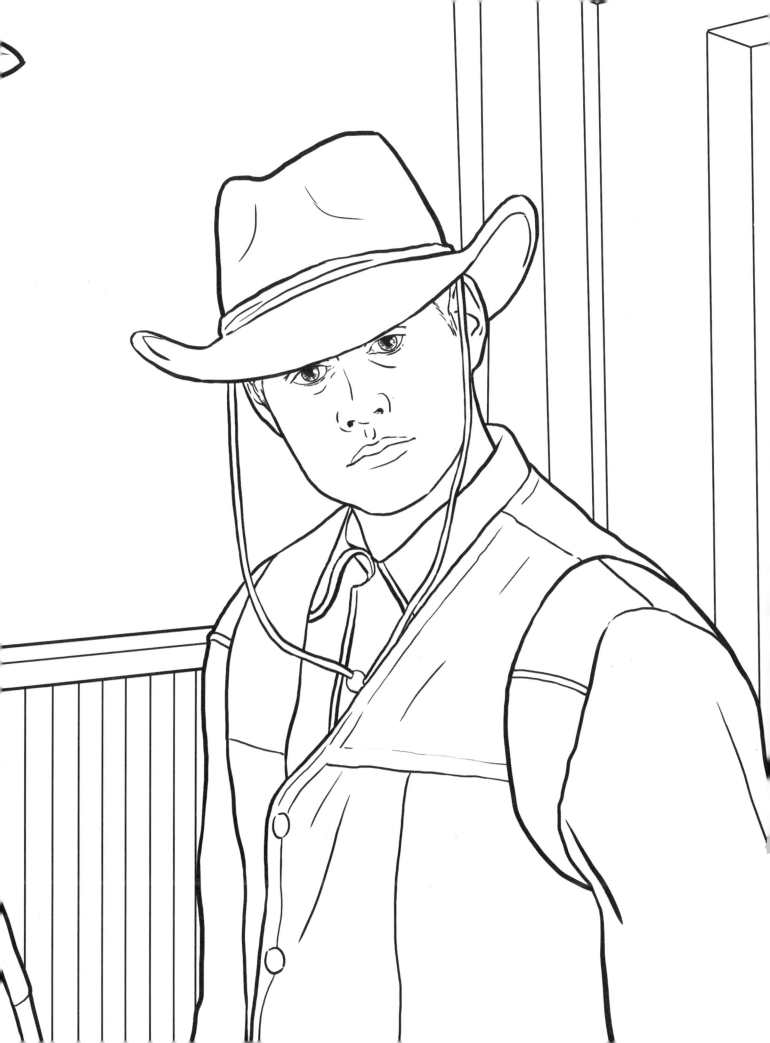

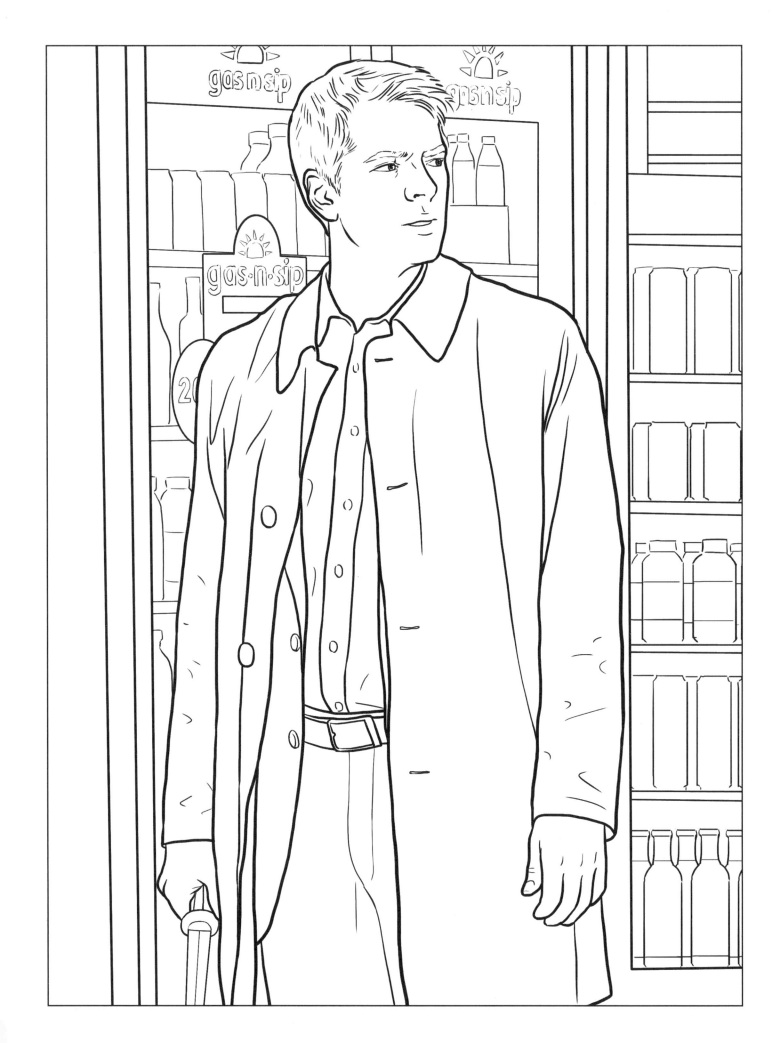

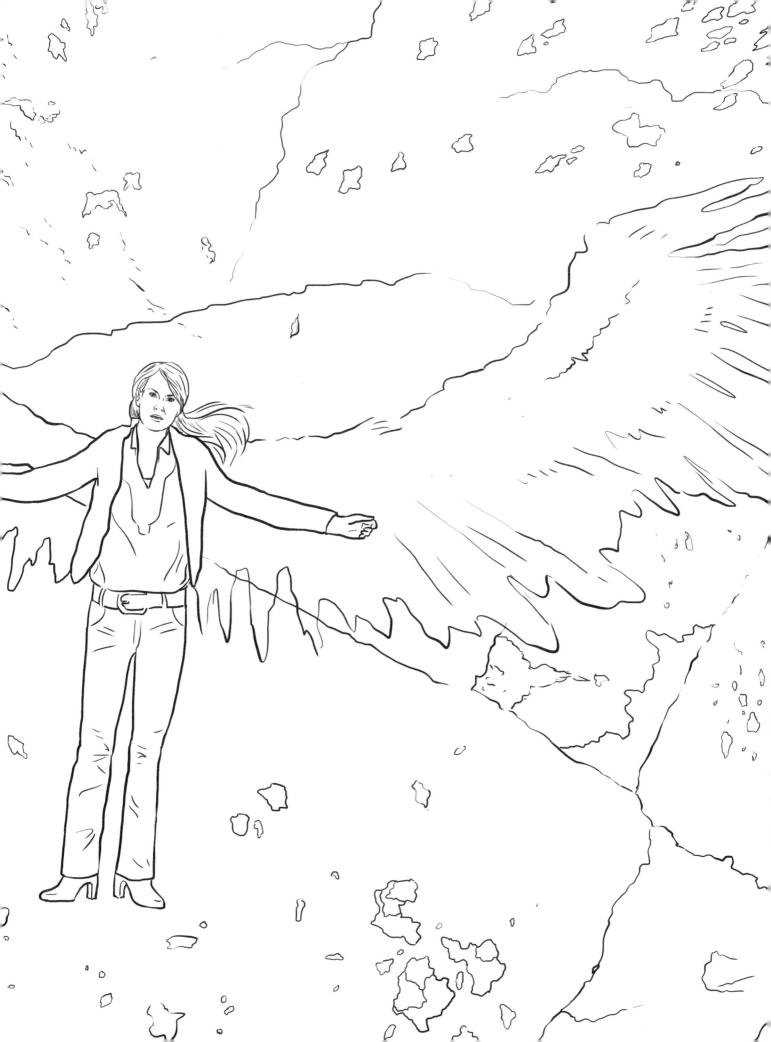

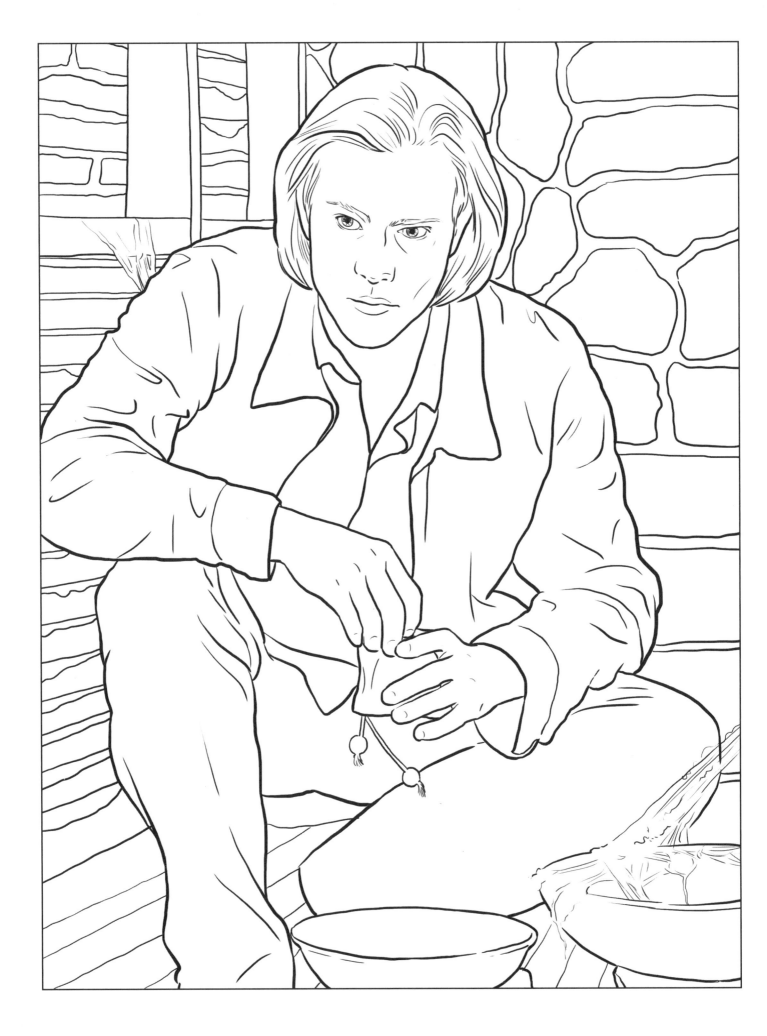

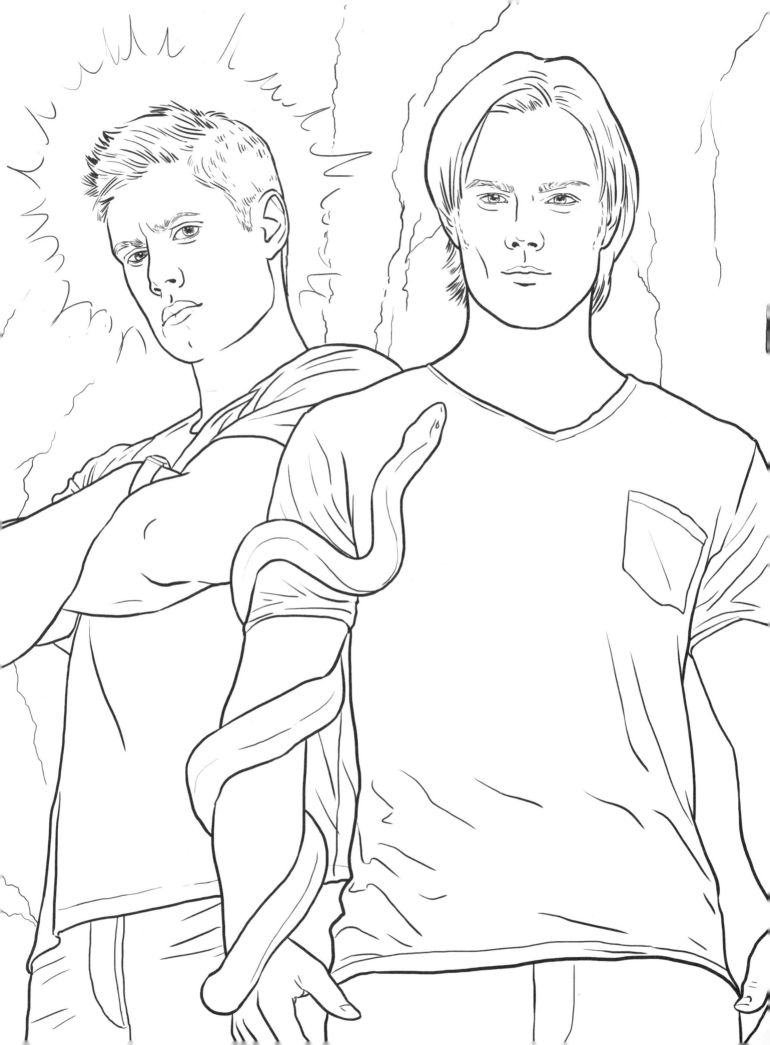

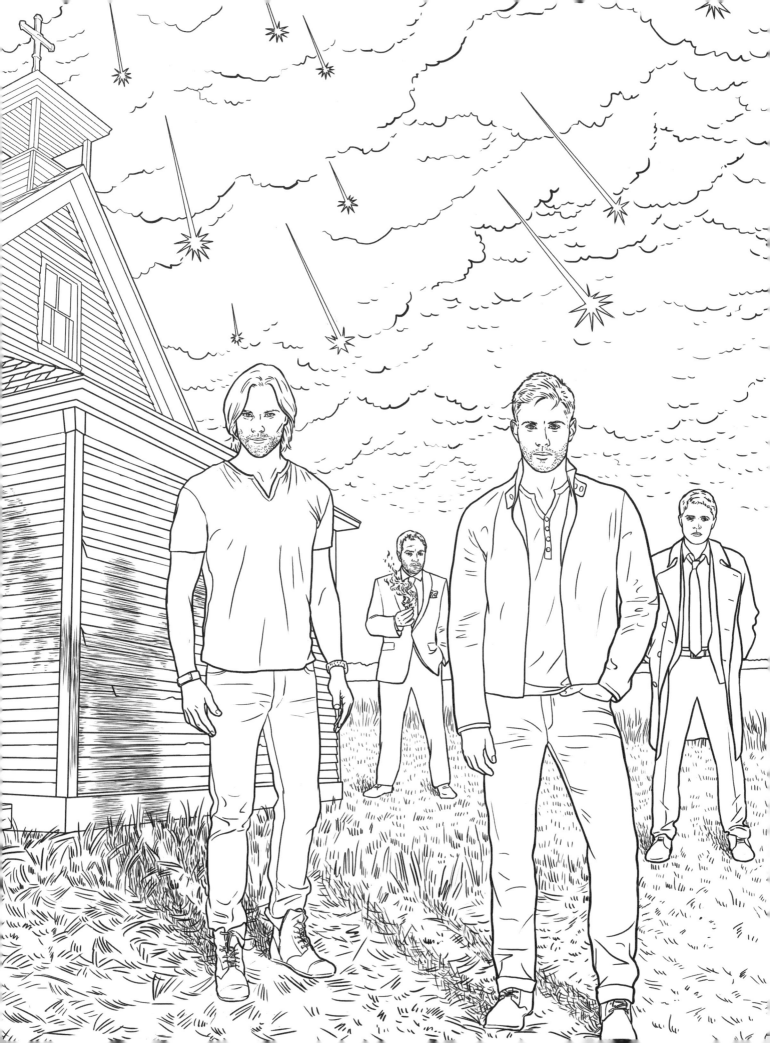

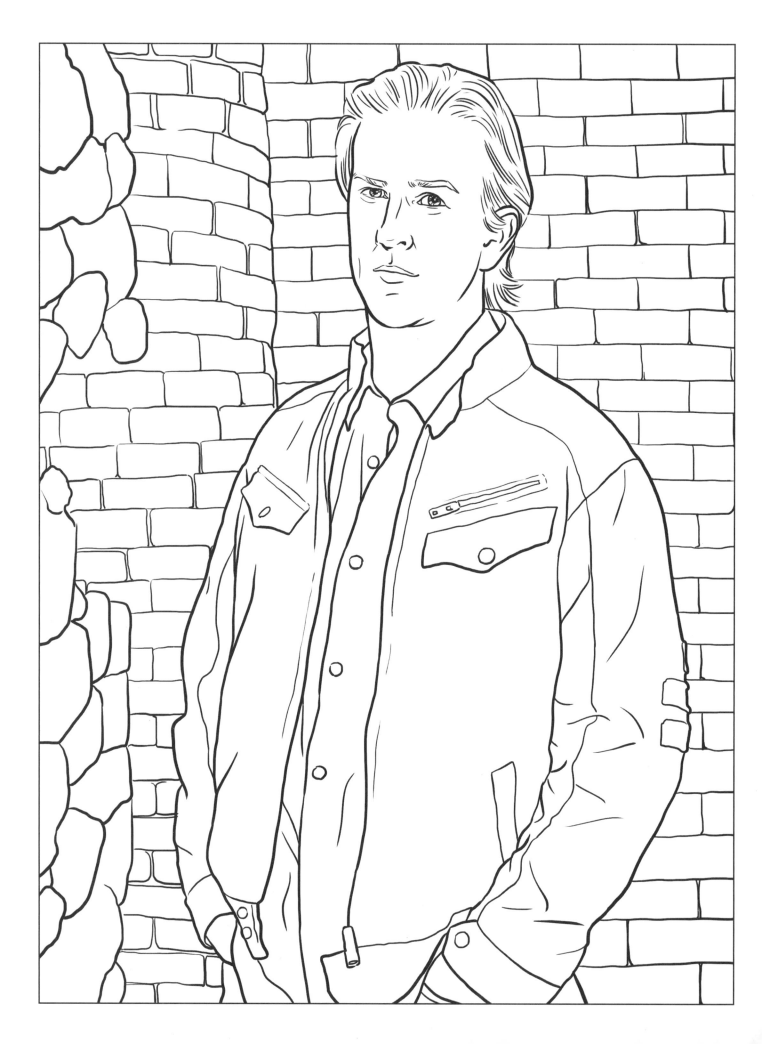

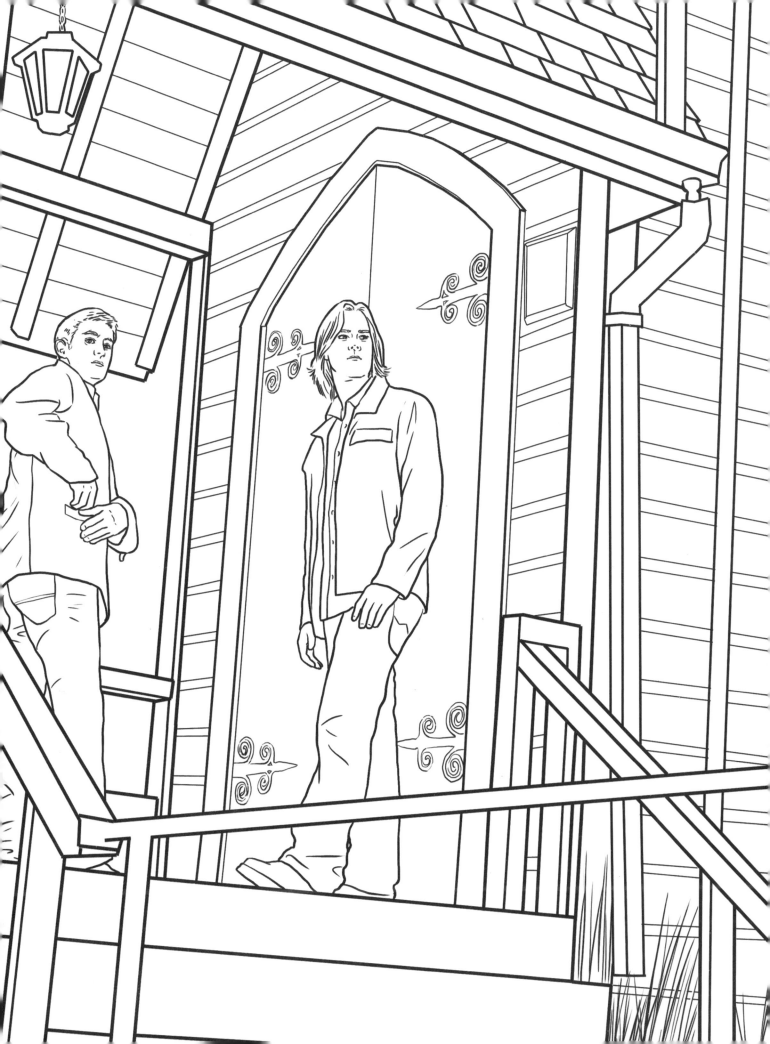

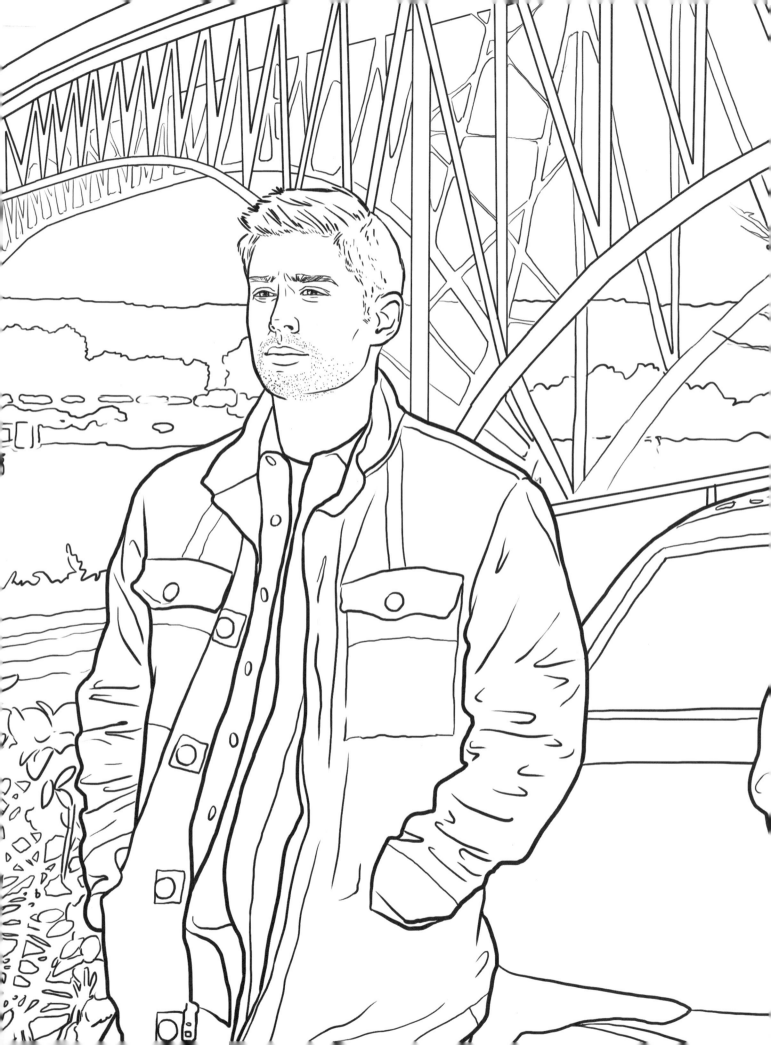

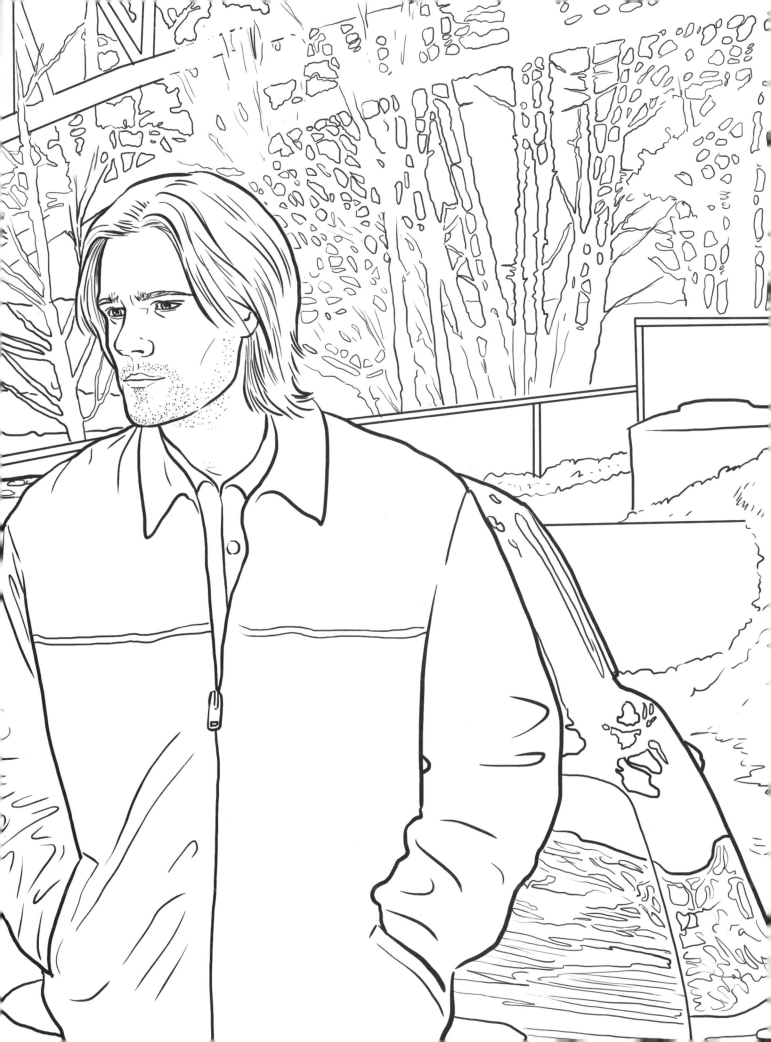

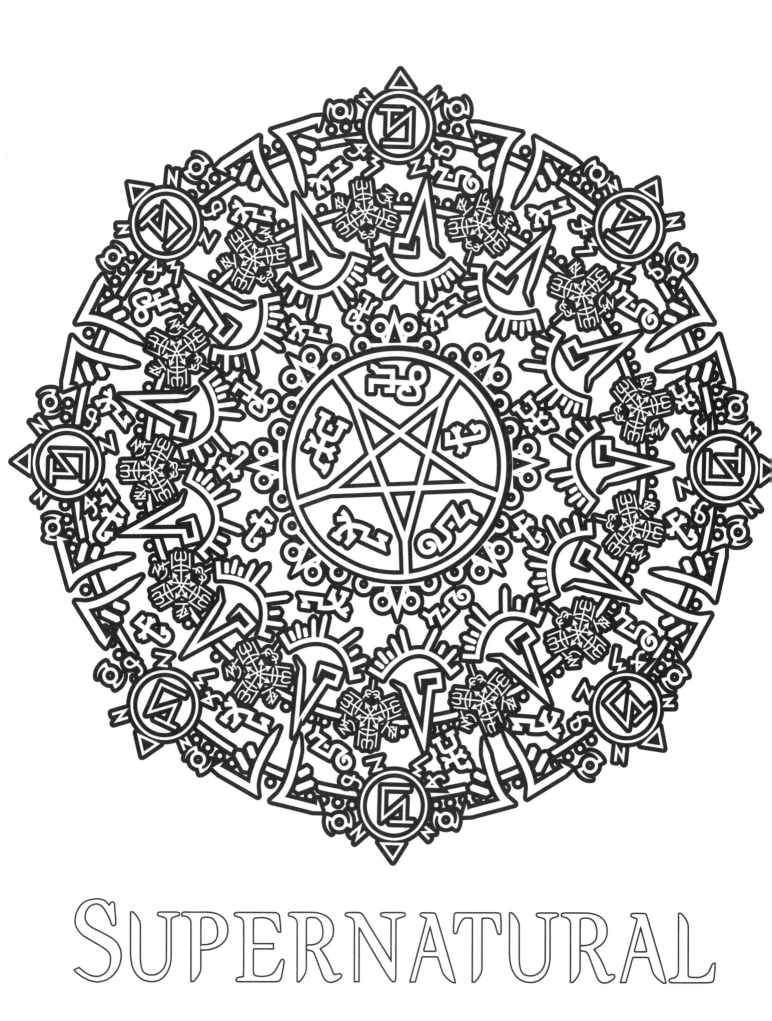

SUPERNATURAL

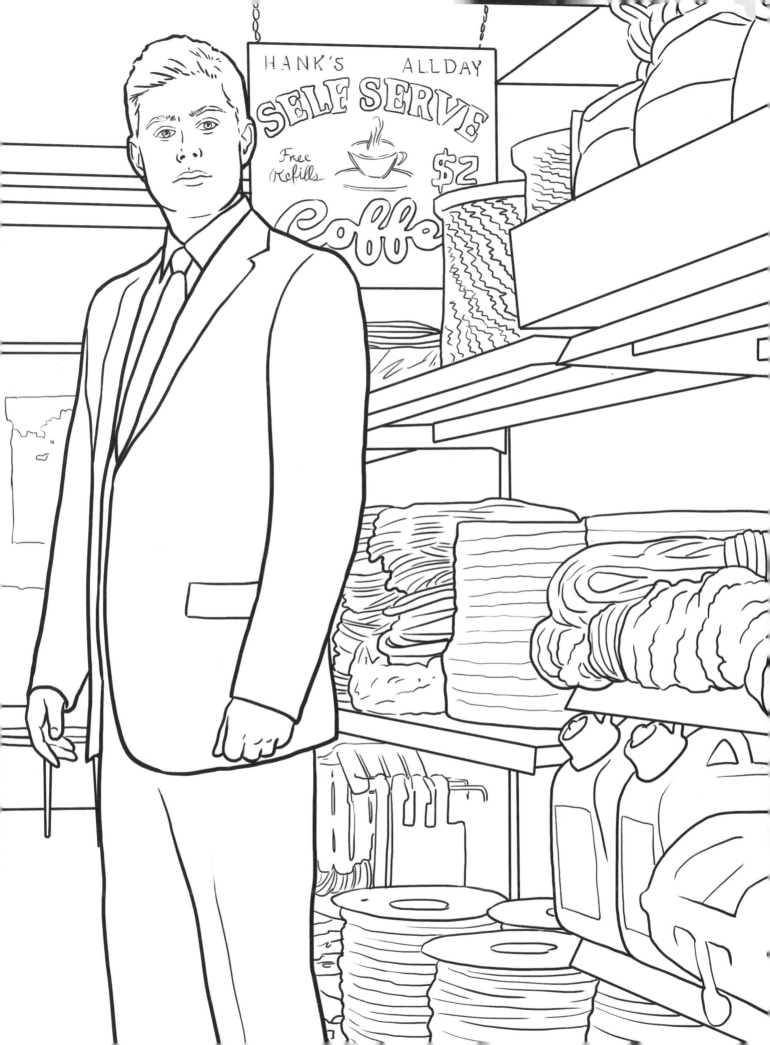

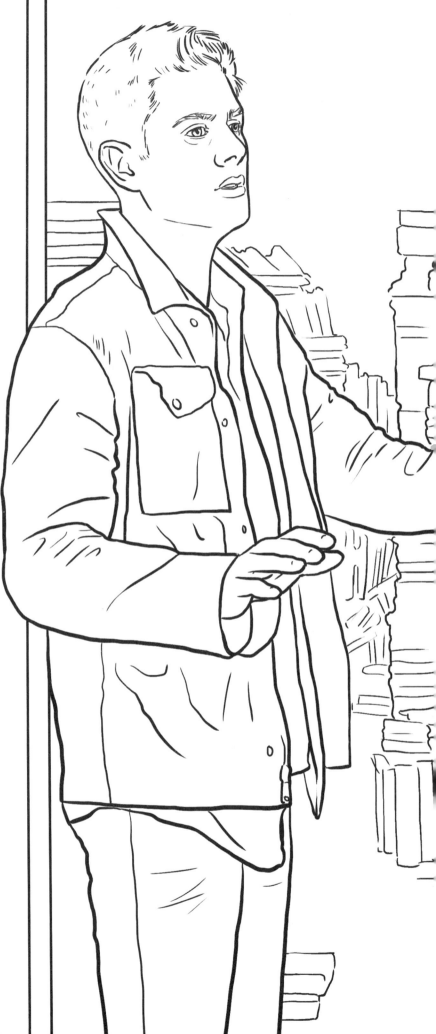

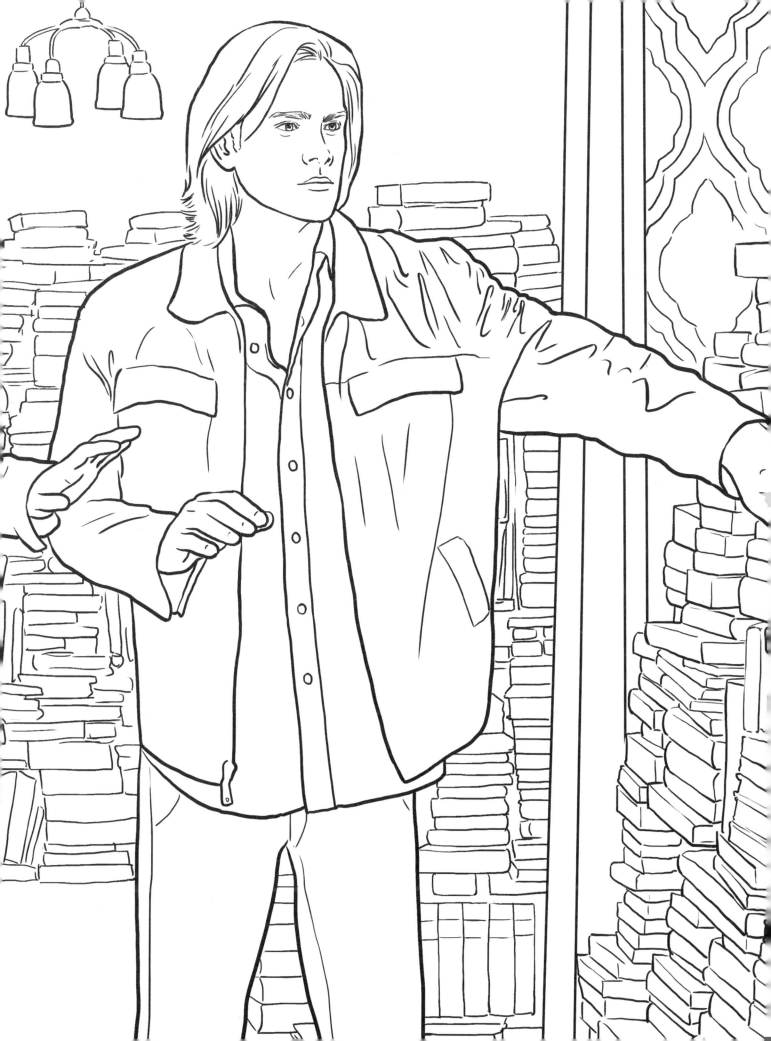

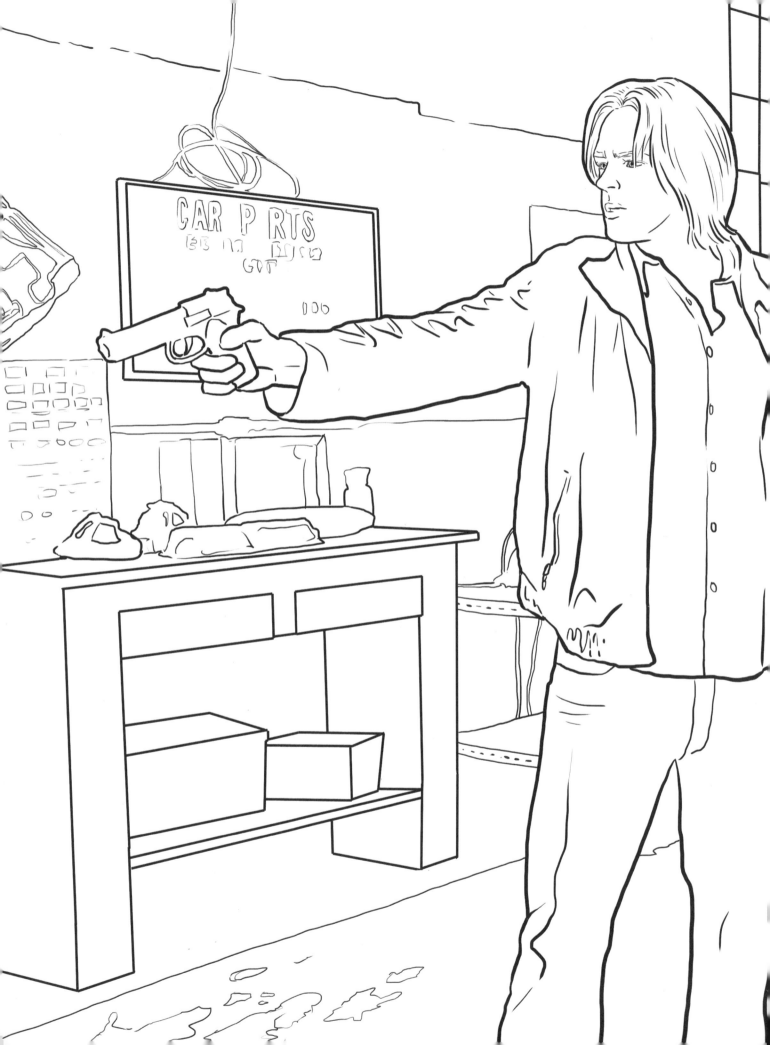

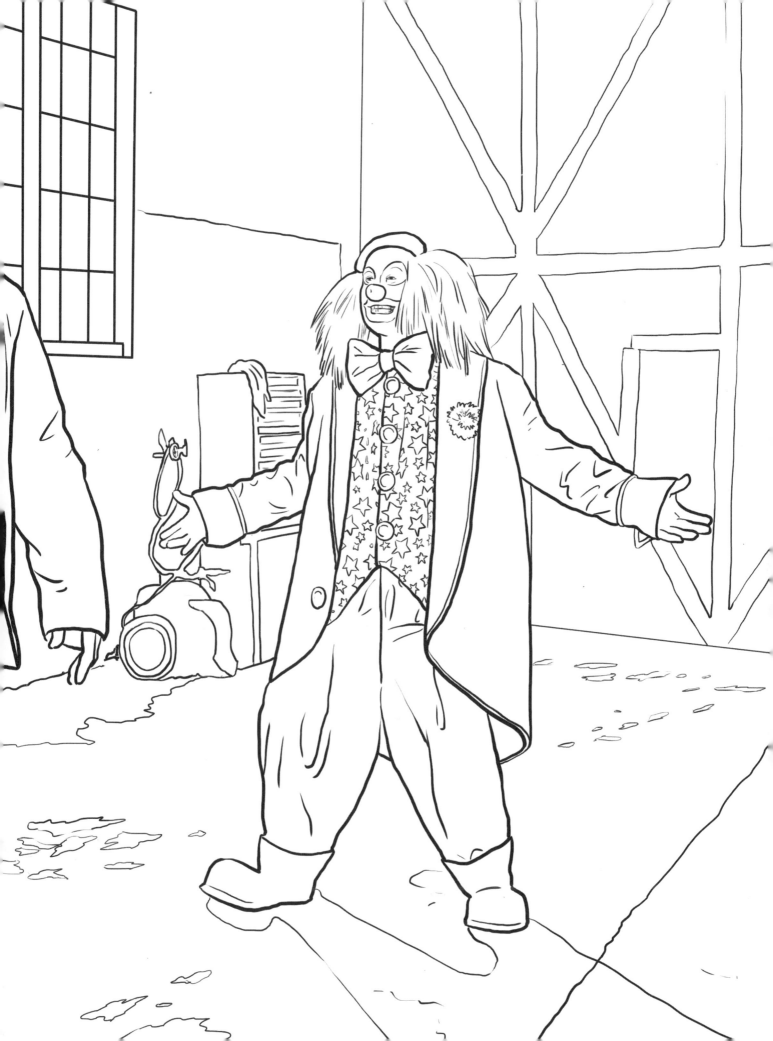

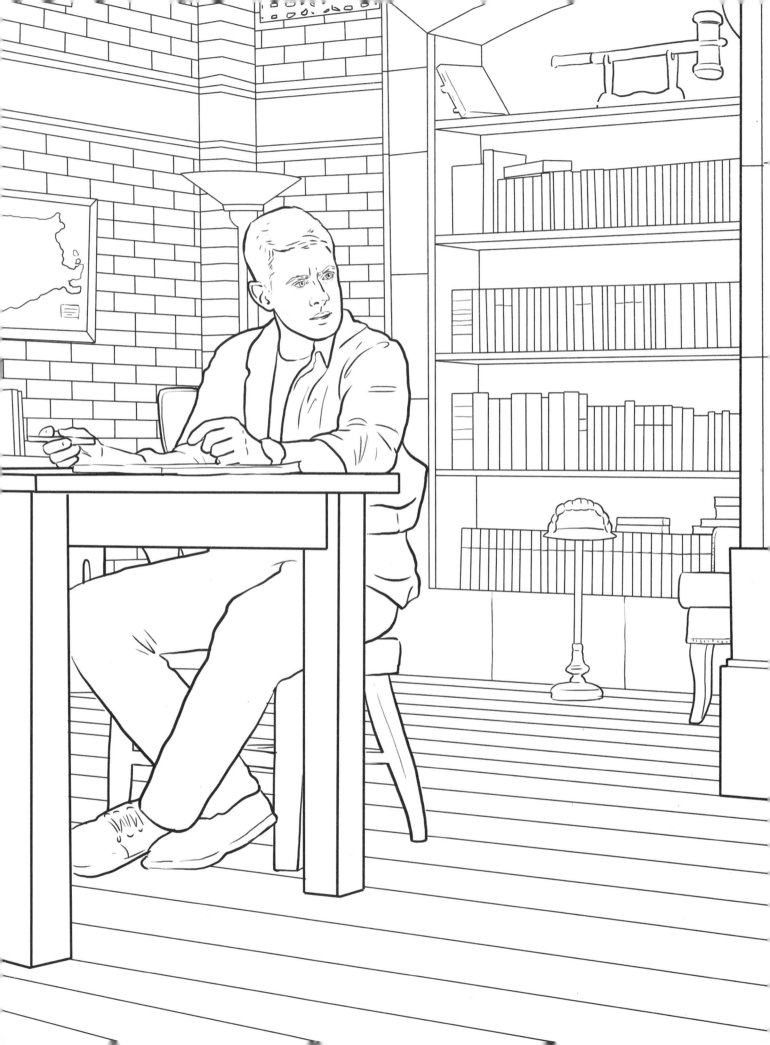

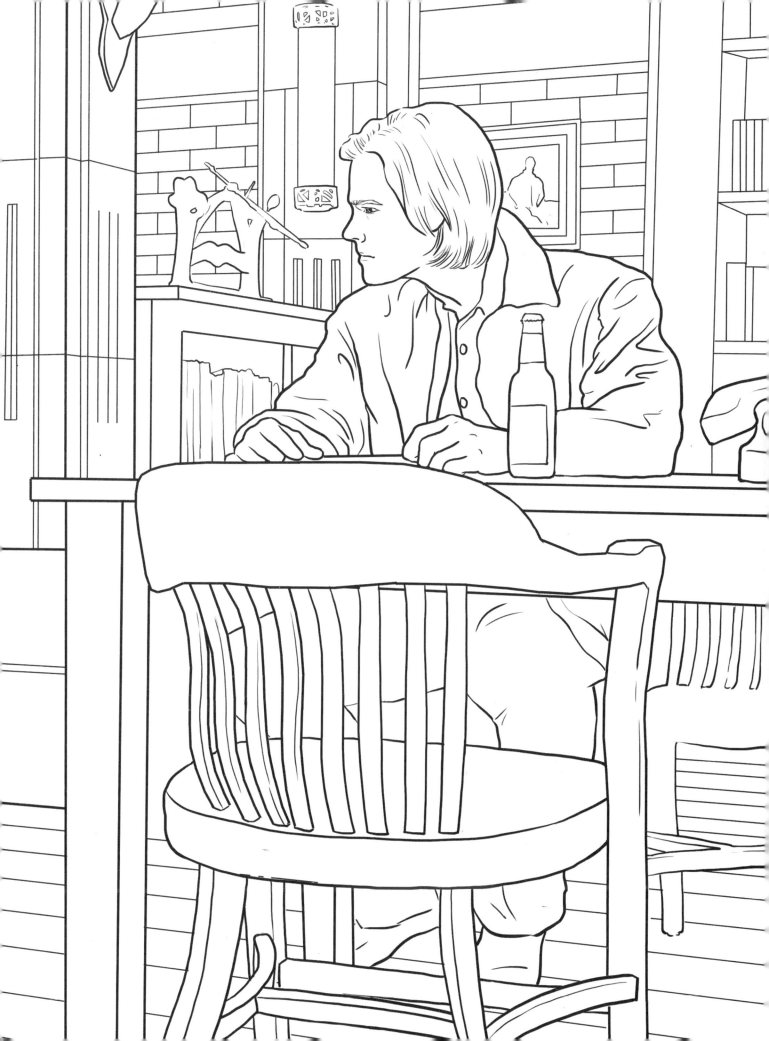

DRAW YOUR WORST FEAR

PLUCKY WILL MAKE YOUR FEAR DISAPPEAR

PLUCKY PENNYWHISTLE'S MAGICAL MENAGERIE!

THE **Aviary**
HOTEL

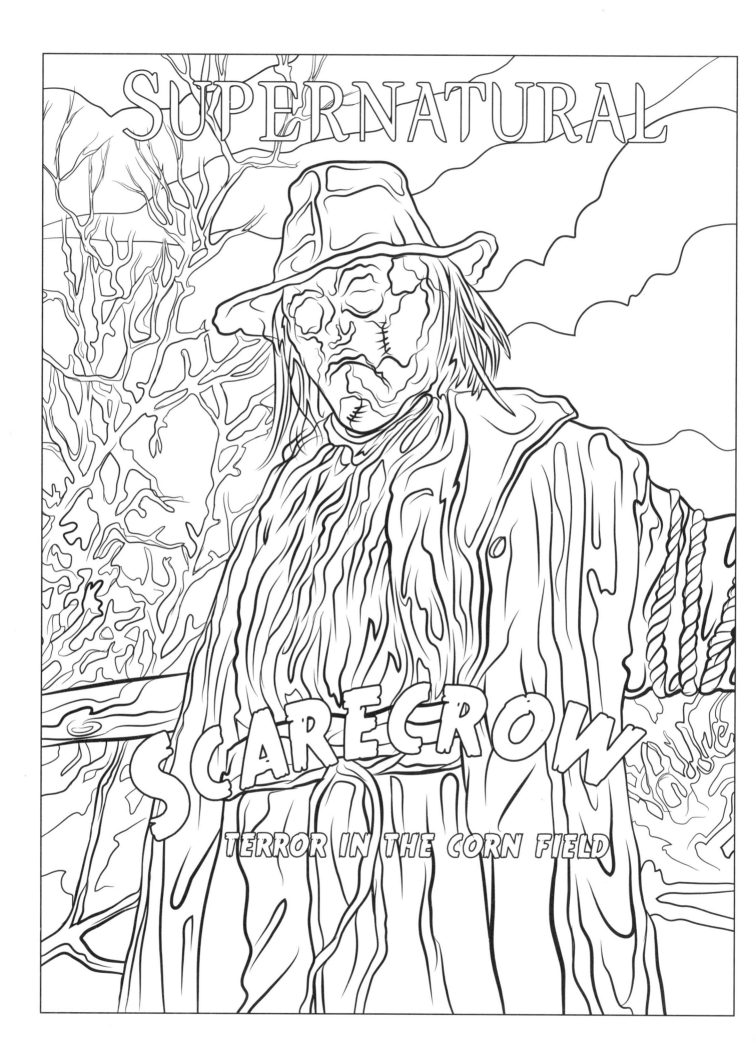

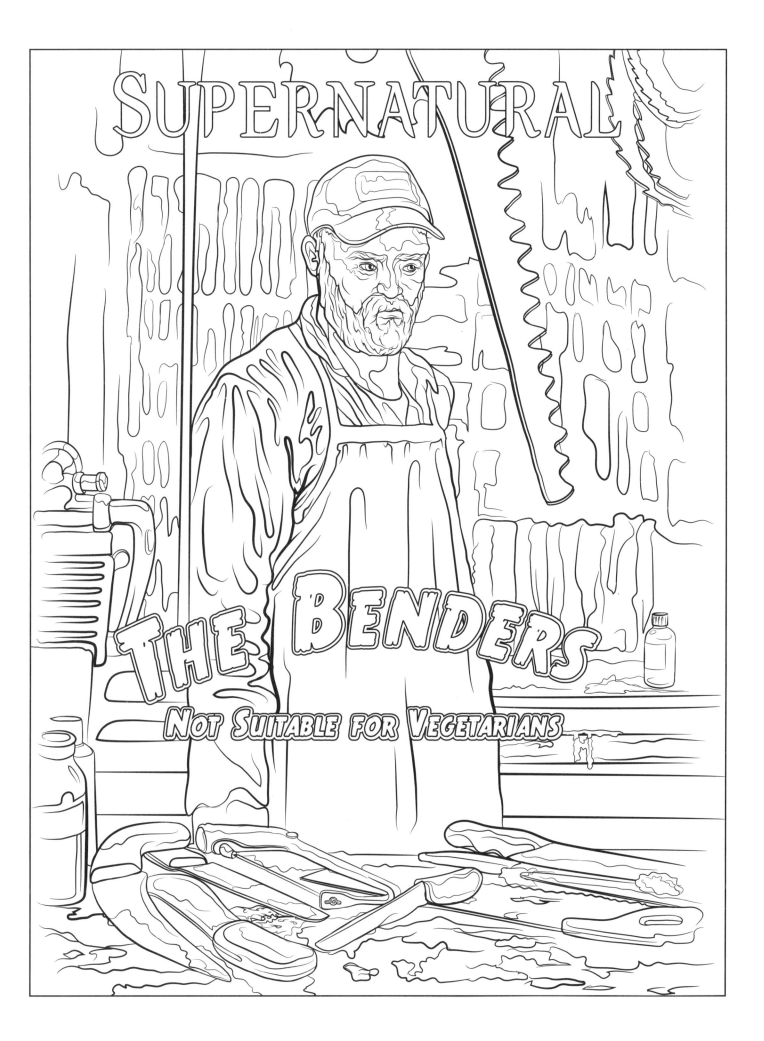

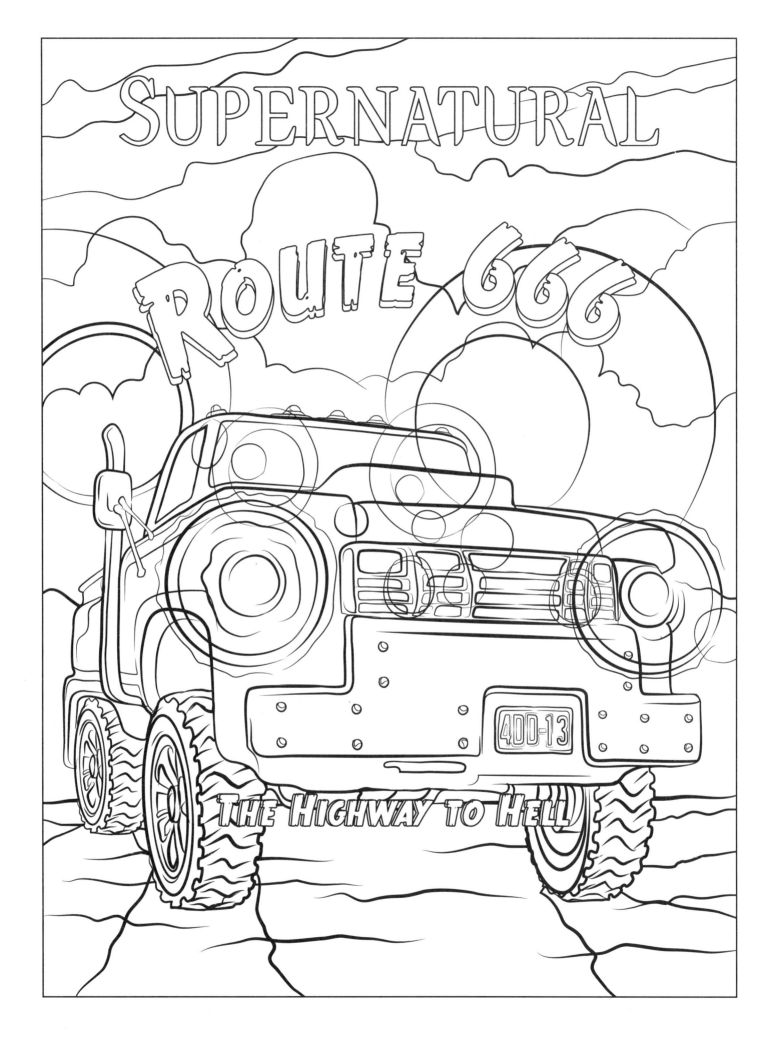

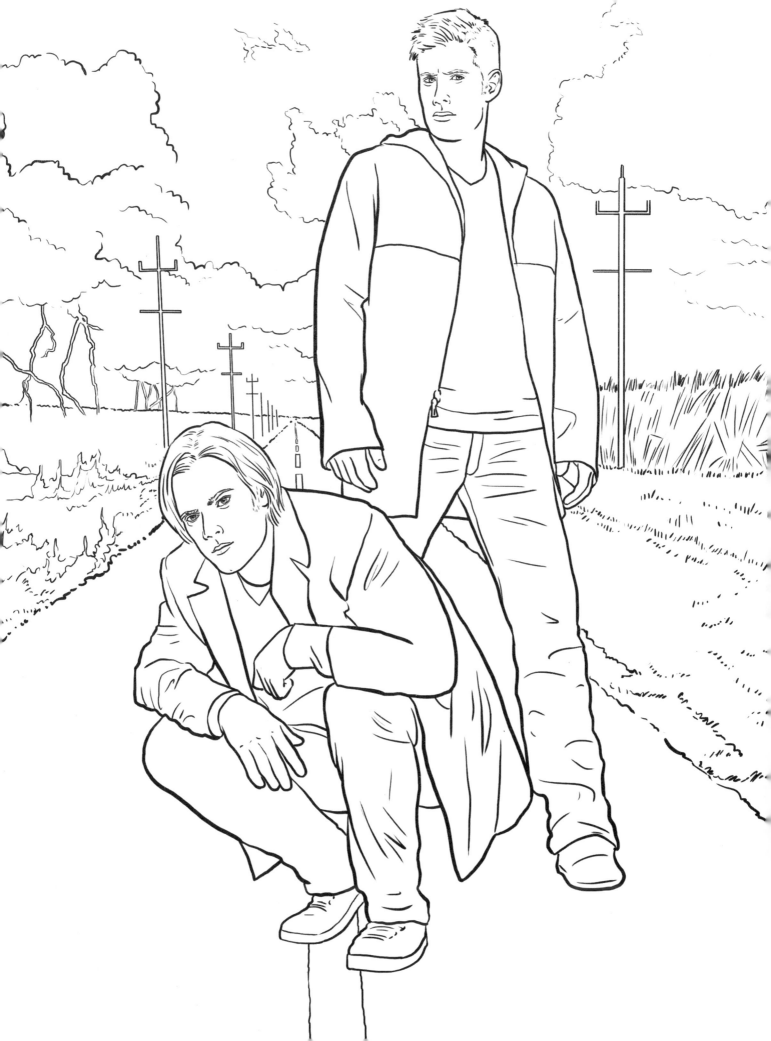

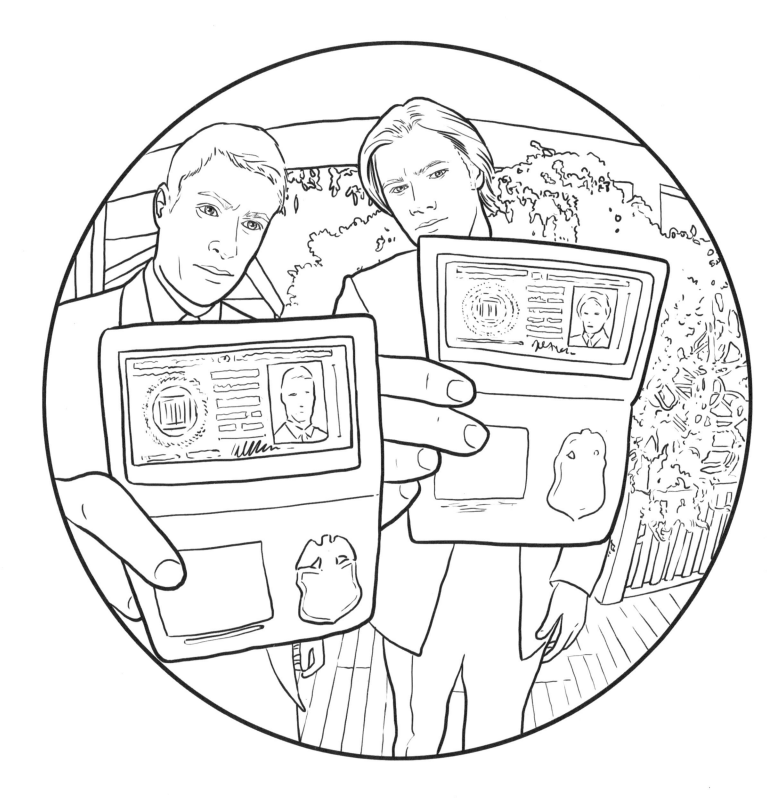

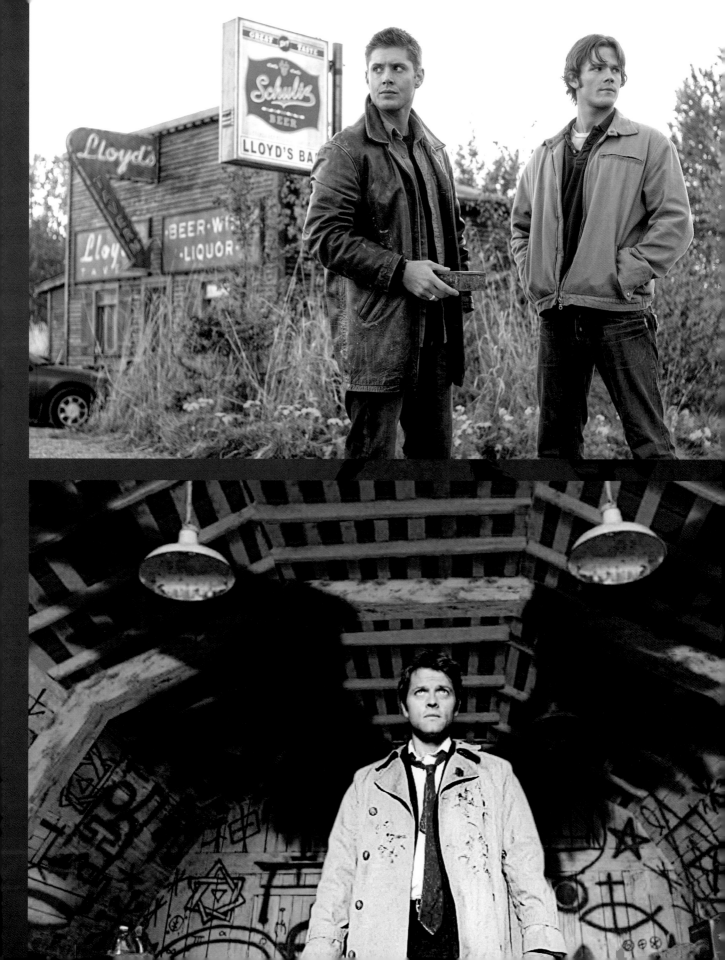

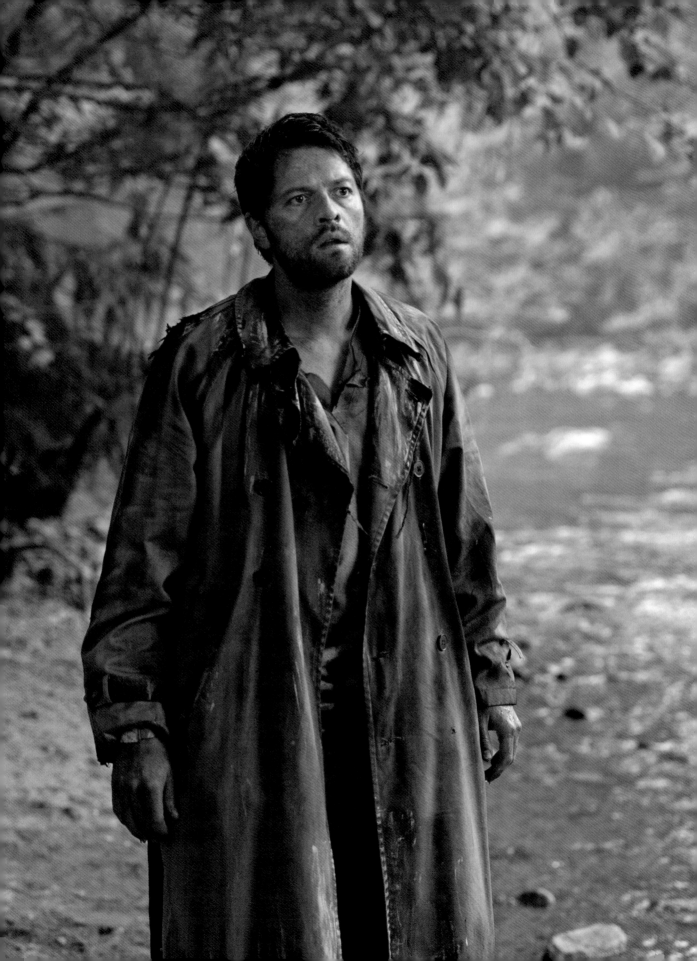

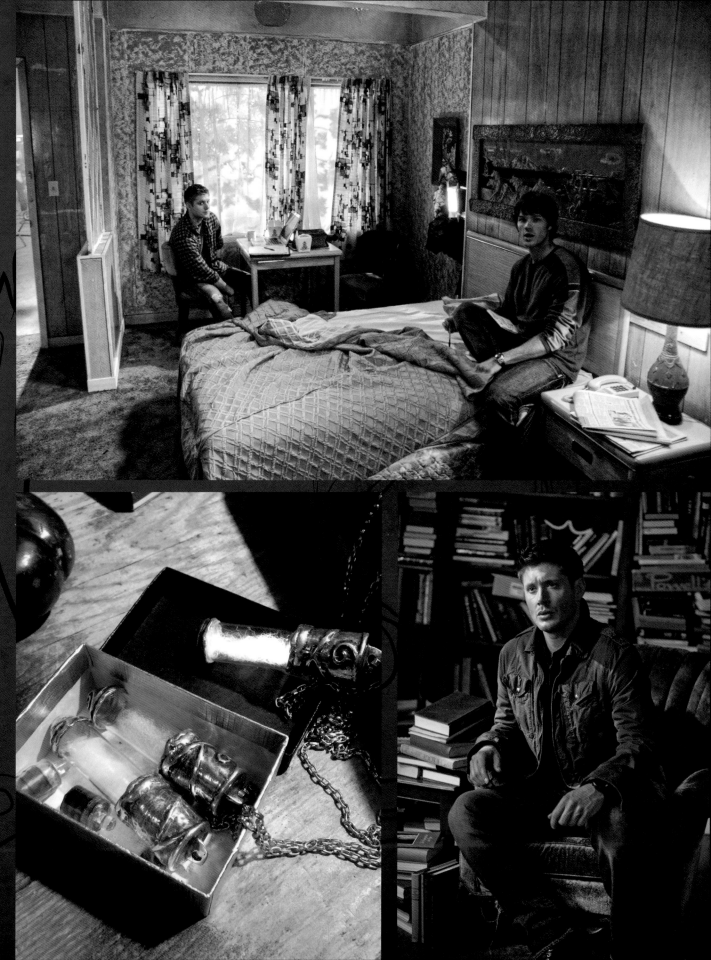

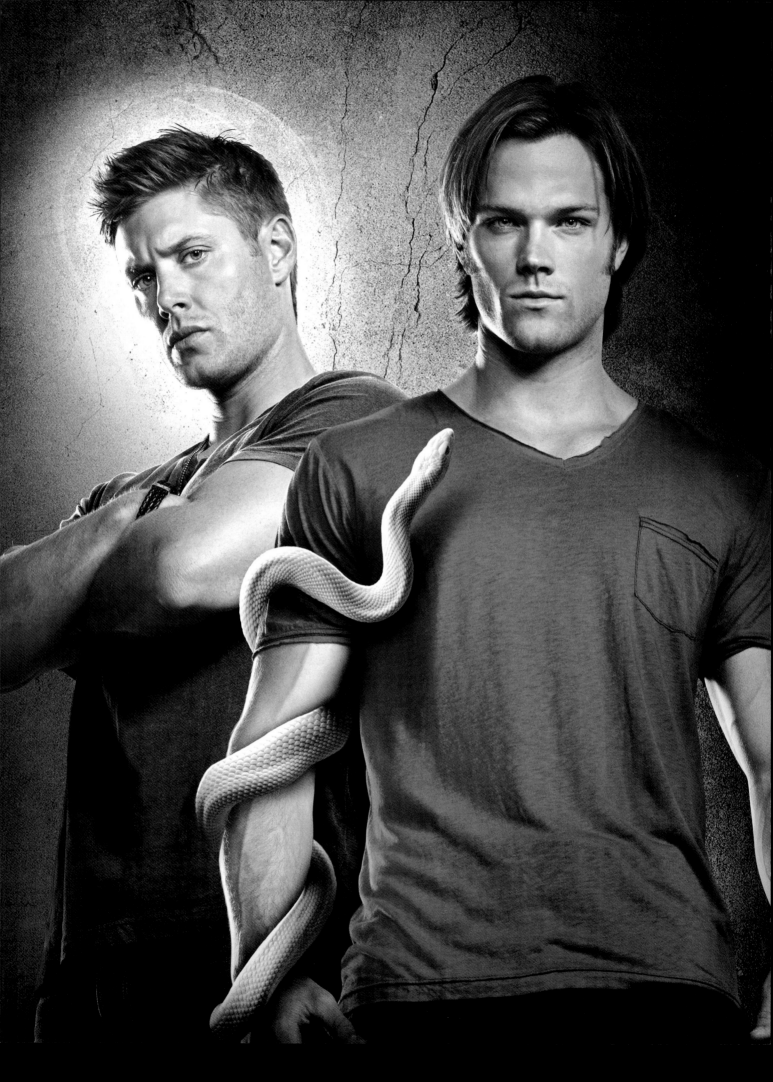

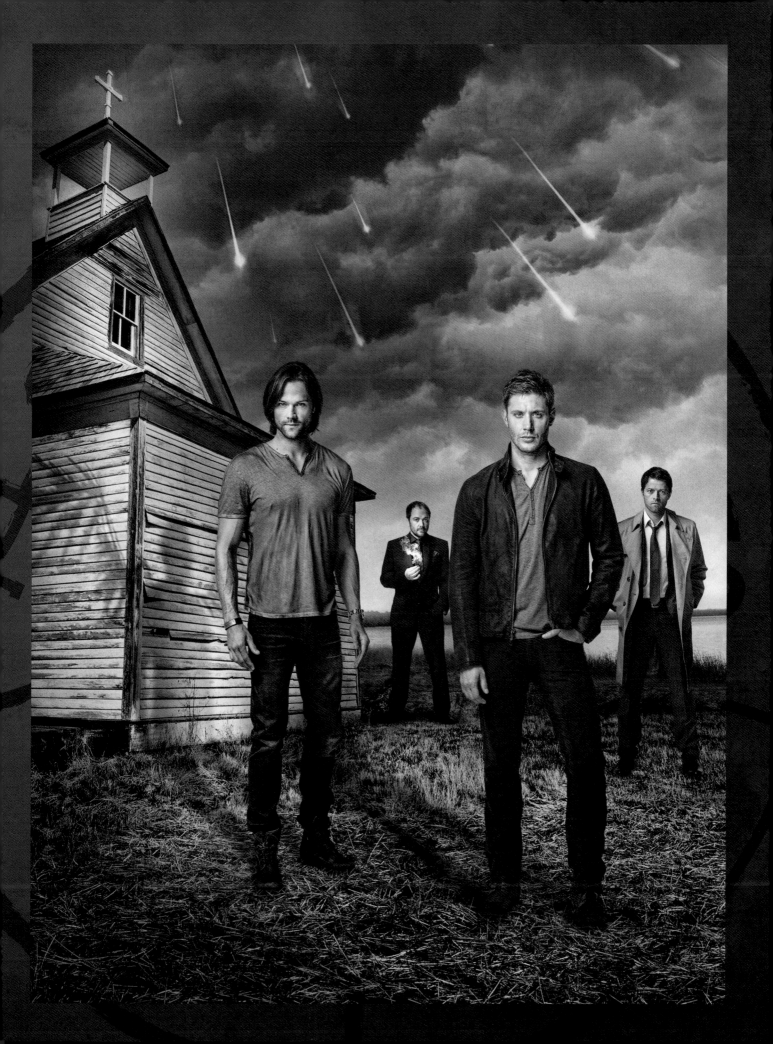

SUPERNATURAL

by Carver Edlund

SCARECROW
TERROR IN THE CORN FIELD

A visit to Burkitsville, Indiana reveals a terrifying secret in the sleepy rural town. Can Sam and Dean put their differences behind them and stop the next sacrifice?

"A very scary read, indeed. Hey - that rhymes."
George Neuman, Comic Addicts Monthly

Flying Wiccan
PRESS

#10

PRINTED IN THE USA

SUPERNATURAL

by Carver Edlund

ROUTE 666
THE HIGHWAY TO HELL

When Dean's old flame needs help, the boys come to the rescue. Our heros investigate a series of racially motivated murders in Missouri. A large black truck with an impressive lift kit is implicated in the crimes.

"This ain't your average truck, and I'm not just talkin' about the engine."
Jeff Budnick, Comic Universe

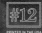

Flying Wiccan
PRESS

#12

PRINTED IN THE USA

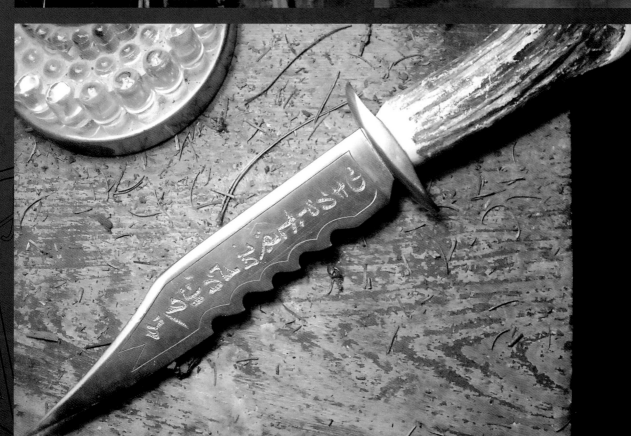

**INSIGHT
EDITIONS**

PO Box 3088
San Rafael, CA 94912
www.insighteditions.com

Find us on Facebook: www.facebook.com/InsightEditions
Follow us on Twitter: @insighteditions

Copyright © 2016 Warner Bros. Entertainment Inc.
SUPERNATURAL and all related characters and elements are
trademarks of and © Warner Bros. Entertainment Inc.

www.cwtv.com/supernatural

Published by Insight Editions, San Rafael, California, in 2016.
All rights reserved. No part of this book may be reproduced in any
form without written permission from the publisher.

Library of Congress Cataloging-in-Publication Data available.

ISBN: 978-1-60887-818-5

Publisher: Raoul Goff
Acquisitions Manager: Robbie Schmidt
Art Director: Chrissy Kwasnik
Executive Editor: Vanessa Lopez
Production Editorial Manager: Alan Kaplan
Project Editor: Katie DeSandro
Production Editor: Elaine Ou
Junior Production Manager: Alix Nicholaeff

Illustrations by Robin F. Williams and Adam Raiti

REPLANTED PAPER

Insight Editions, in association with Roots of Peace, will plant two
trees for each tree used in the manufacturing of this book. Roots
of Peace is an internationally renowned humanitarian organization
dedicated to eradicating land mines worldwide and converting war-
torn lands into productive farms and wildlife habitats. Roots of Peace
will plant two million fruit and nut trees in Afghanistan and provide
farmers there with the skills and support necessary for sustainable
land use.

Manufactured in China by Insight Editions

20 19 18 17 16 15 14 13 12

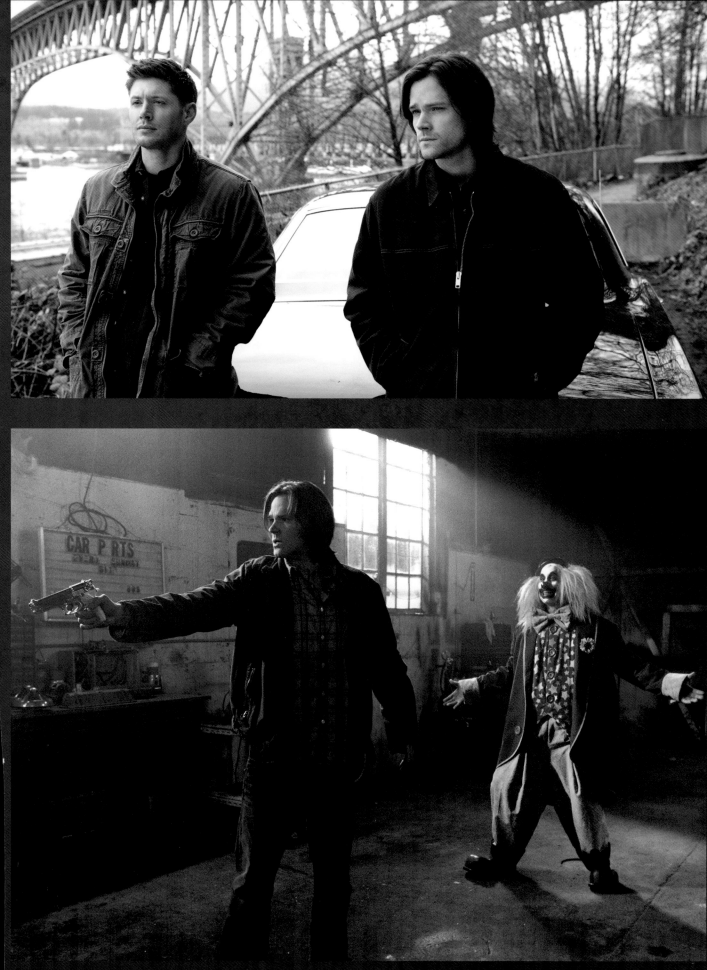